IRISH COUNTRY HOUSEHOLDS

'A COMMON CELTIC PAST'

*T*he Shannon Heritage portfolio has developed over the past 35 years from one product in 1963 which was the Medieval Banquet at Bunratty Castle to a total of 8 day visitor experiences and 4 evening entertainments.

All of the expertise gained over the years is brought to bear to ensure that all of our visitors have a fun, value for money experience.

'A COMMON CELTIC PAST'

is the theme for an adventure through time. The story brings the visitor into the magic and mystery of the pre-historic, Celtic, Viking, Anglo-Norman, and native `Irish Societies starting 5,000 years ago and continuing to the present.

Our Celtic heritage is shared with many of our European neighbours. The Celts were an artistic and technologically advanced people who spread throughout Europe bringing with them their language and culture.

We invite our visitors to come with us on this journey of discovery as we reveal some of the milestones through

PEOPLE, PLACES, STORIES
SONG AND DANCE

which have shaped our destiny and made us the 'Irish Celts' we are today.

IRISH COUNTRY HOUSEHOLDS

KEVIN DANAHER

MERCIER PRESS

First published by Mercier Press in 1985

This printing 1999
PO Box 5 5 French Church St Cork
Tel: (021) 275040; Fax: (021) 274969;
e.mail: books@mercier.ie
16 Hume Street Dublin 2
Tel: (01) 661 5299; Fax: (01) 661 8583;
e.mail: books@marino.ie

Trade enquiries to CMD Distribution
55A Spruce Avenue
Stillorgan Industrial Park
Blackrock County Dublin
Tel: (01) 294 2556; Fax: (01) 294 2564
e.mail: cmd@columba.ie

ISBN 0 85342 734 8
10 9 8 7 6 5 4 3 2
A CIP record for this title is available from the British Library

Cover photographs courtesy of Shannon Heritage
Printed in Ireland by ColourBooks, Baldoyle Industrial Estate, Dublin 13

Contents

Bunratty House.

FOREWORD TO 1985 EDITION

'An Old Woman of the Roads', a poem by Padraic Colum, tells of the longing of a poor old woman to have a house of her own, like the house-proud if humble people whose homes she passed every day in her wanderings. If she could walk the roads today she might well be amazed at the rapid vanishing of the old-fashioned dwellings that were characteristic of the Irish countryside up to a couple of decades ago, and even more so if she stepped inside one of our modern kitchens.

We are glad that a few places like Bunratty Folk Park gave us the opportunity of seeing how our rural grandparents lived, and we are grateful to the management of the Folk Park, who have kindly allowed us to use it as the background to this brief look at the houses and the housekeeping of our recent past, now gone for ever.

Our thanks are especially due to the Bunratty Folk Park authorities, that is to say the Shannon Free Airport Development Company, for providing us with most of the photographs and drawings. We owe thanks, too, to the Deaprtment of Irish Folklore, University College Dublin, for the following supplementary photographs: 46 and 47 (by Å Campbell); 22, 58 and 66 (C. Ó Danachair); 44 (D. Ó Cearbhaill); 53 (H. Hjort); 23 (M. Curtin); 54 and 55 (W. Danaher) and 45 (L. Corduff). All of the drawings are the work of K. D. O'Brien.

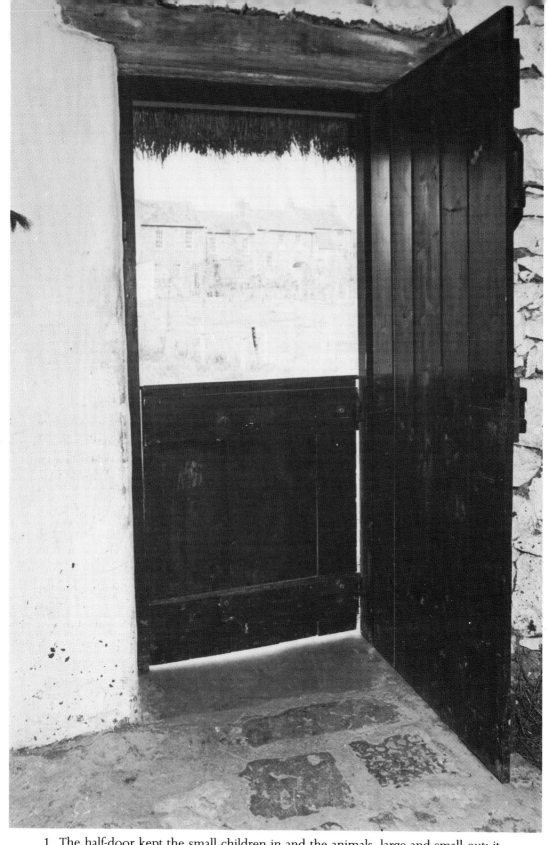

1. The half-door kept the small children in and the animals, large and small out; it also gave welcome ventilation.

1

Into the Past

This is a short journey into the past. Short, indeed, because this work will not take long to read, but more significantly short because we are going only a few steps back, only two or three generations, only eighty or a hundred years, only to a time when people that we knew, or that our parents knew, were still alive.

How different was life then? If we could be transported by some time-machine back into the world of a century or so ago what changes would we see and hear and feel? Would life be better or worse than it is now? We all have heard old people lamenting the passing of the 'good old days', but were they really so good? There are others who say that life in 'the old days' was mean and poor and miserable. How would we, our time journey accomplished, find it? How would we respond to it or react against it?

The greatest difference for us would lie in what was missing. Most of the things which have become indispensible to us in our daily lives simply did not exist for our great-grandparents, some of them utterly undreamed of, some so remote as to have no significance.

Most of all we would feel the absence of the motor engine, electric power and radio-television. It is true, of course, that in Germany Herr Daimler and Herr Benz had sunk their inventive rivalry to produce the first practical motor car, and there were rumours of the appearance of the horseless carriage in one or other part of Ireland. Many people had seen gas lighting in one of the larger towns, and the newfangled electric light had become known. Telegrams were known, but they were a cause of trepidation – a telegram usually told of the death of a relative; more cheerful news could wait for a letter. But the telephones of Mr Bell and Mr Edison had reached only to some big business and government services. For active and romantic young minds there was the science fiction of Monsieur Jules Verne, telling of high adventure from the centre of the earth to the moon while that new English author, Mr Wells, was writing of journeys into the future and invasions from Mars. All these wonders, however, had little effect on the lives of ordinary people, for

whom the paraffin lamp, the horse-cart and the weekly newspaper provided light, transport and a view of the world.

Much of the work entailed by the absence of the labour saving devices which we know today in the fields and the factory, the office and the home, would seem mere drudgery to us but were accepted as normal in their time. Against the drudgery we can set the fact that there was less noise, less dirt, less pollution, less stress and less fear. Oil spillage and acid rain had not been heard of. No overflowing refuse dumps, no foul scum on the sea, no roar of engines on the road, no lead and sulphur-laden atmosphere, no jet trails in the sky. And, above all, no fear of some mad statesman pushing that fatal final button. It is difficult to decide which was really the better life, ours or theirs.

In one thing they had a distinct advantage over us. They were more self sufficient and independent.

In their day-to-day lives they could provide for most of their needs. Many of them could build their own houses, raise their own food, provide their own fuel and light, control their own water supply and contrive dozens of minor expedients of everyday need. Breakdowns and strikes and international disputes affected them little and worried them less; these happenings were remote from them, a rumour heard on fair or market day, or a paragraph in a week-old newspaper, calling for a moment of interest or wonder or pity, nothing more, all very far away from their own secure little world.

If you walk around the Folk Park in Bunratty you will be stepping back into the past, and with a little imagination you can call to life much of the spirit of the past. To help you on your way the following pages will give you, first a brief note on the various dwellings and those who lived in them, and then a general description of their household economy.

THE SHANNON FARMHOUSE

This homestead once stood where a runway of Shannon Airport now stretches and was the first building to be re-erected in the Folk Park. A typical small farm of this kind on the bank of the Shannon would have about twenty acres of good land and another twenty of water meadow, and would support about twelve cows, with some dry stock and smaller animals.

The stone chimney breast has a shelf for candlesticks and ornaments, and on the left of the chimney some steps lead to a storage loft. Below the kitchen are two bedrooms, one, reached by a ladder, over the other, while above the kitchen is the parlour, with its effort at Victorian elegance.

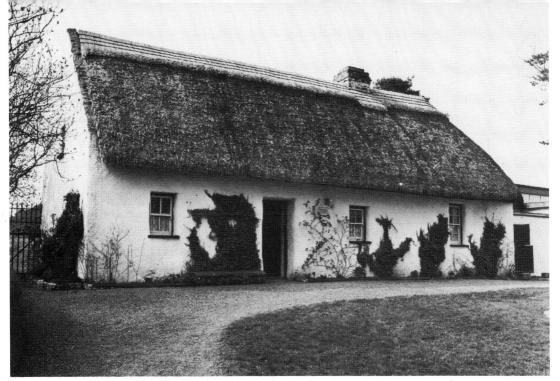

2. The Shannon farmhouse.

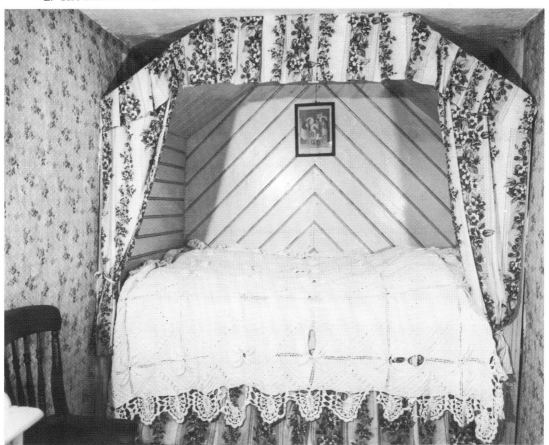

3. The 'covered-car' bed.

4. The Mountain farmhouse.

Note the hen-coop, the settle bed and the spit dresser. The little perch over and behind the front door is where the rooster perched at night, his function being to arouse the household by crowing at dawn.

In the lower bedroom is a fine example of a 'covered-car' bed, boxed in wood and with a cloth curtain in front for both privacy and shelter.

THE MOUNTAIN FARMHOUSE

A typical dwelling of a farm family of Sliabh Luachra, the upland area in which counties Cork, Kerry and Limerick meet. This is a district where one is never more than a mile or so from bog and heather, with excellent pasture but poor tillage. Dairy farming and dry-stock raising are the staples of life here, with much meadowing but only small crops of potatoes and oats, mangels and turnips. About ten acres of arable land was balanced by some eighty acres of rough pasture and bog, and supported six cows, with calves, pigs and fowl. Turf, cut in the bog and sold in the town, brought a small but sure income.

Note the chimney canopy of plastered wickerwork with its small side lofts and the flagged floor which a century and a half ago formed part of

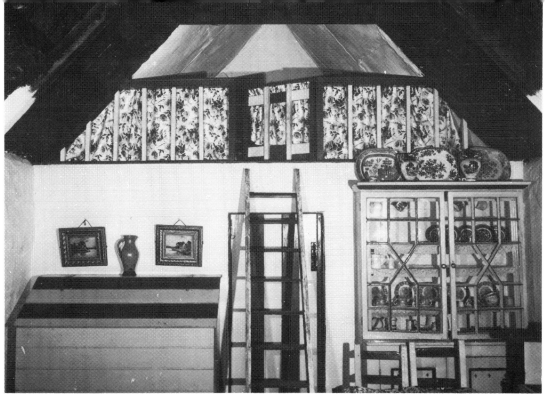

5. Inside the Mountain farmhouse. Note the open loft and the door to the lower
 room with china press on one side and flour bin on the other.

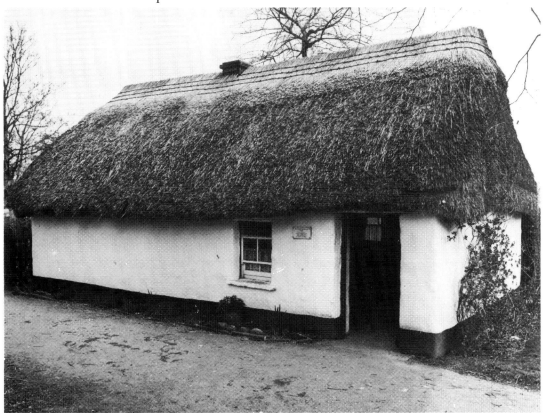

6. The Cashen fisherman's house.

the dowry of a girl marrying the son of the house. The flour bin against the partition is matched by a handsome glass-fronted cupboard made about 1890 by a country carpenter. The open fronted loft over the lower room was the children's bedroom; here they fell asleep within sight and sound of the company in the kitchen. The parlour above the kitchen is typical of the upward social movement of the nineteenth century, as is the handsome bed-head in the bedroom, turned by a country carpenter in County Limerick about 1840. Note, too, the simple but handsome wooden fireplace surround in the bedroom.

THE CASHEN FISHERMAN'S HOUSE

On the south side of the mouth of the Shannon the Cashen river is formed by the confluence of the rivers Feale and Gale, which with their tributaries Sméarlach, Allachán, Úbhla and Claedach and numerous minor streams was one of the best series of salmon waters in Ireland, and the fishermen of the Cashen took full advantage of the harvest of salmon.

This is a simple two-roomed house. A settle bed converted the kitchen into a bedroom when needed. Note the wooden chimney canopy. In the old days of wooden sailing ships, and the too frequent wrecks, shore dwellers depended largely on flotsam and jetsam for their timber, and found use for many other things cast up on the shore. Most of the timbering of this house and its like would be of driftwood, which often came in huge planks and beams. Note the solid bedroom furniture made by a local carpenter-boat builder, and the ceiling of whitewashed canvas covering the bare roof inside.

Smuggling was a feature of life here in the old days and many of the hardy fishermen were familiar with the ports of north-western France and the Channel Islands. Claret and brandy were the local drinks, rather than beer and whiskey, and boats like the Dreóilín Aerach, owned by innkeeper Fitzmaurice of nearby Ballyduff and manned by the Cashen men, are still remembered in local tradition for the dashing and venturesome craft they were.

THE LOOP HEAD HOUSE

This is the homestead of a farmer-fisherman from the western extremity of County Clare. This was a small holding of about twelve acres with three cows, some smaller animals and little more than a potato and vegetable garden in tillage. Fishing supplemented the family income, and at times of the year, such as the autumn mackerel season, the men spent more

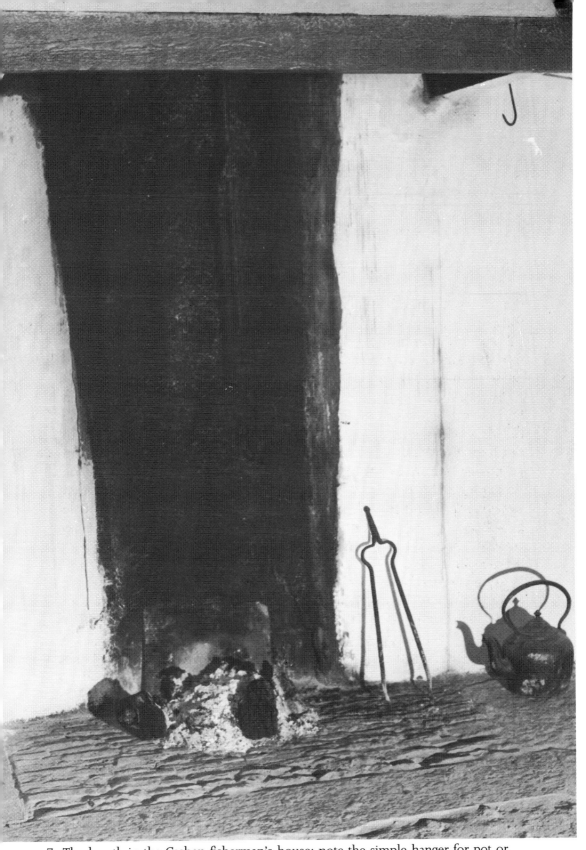

7. The hearth in the Cashen fisherman's house; note the simple hanger for pot or kettle.

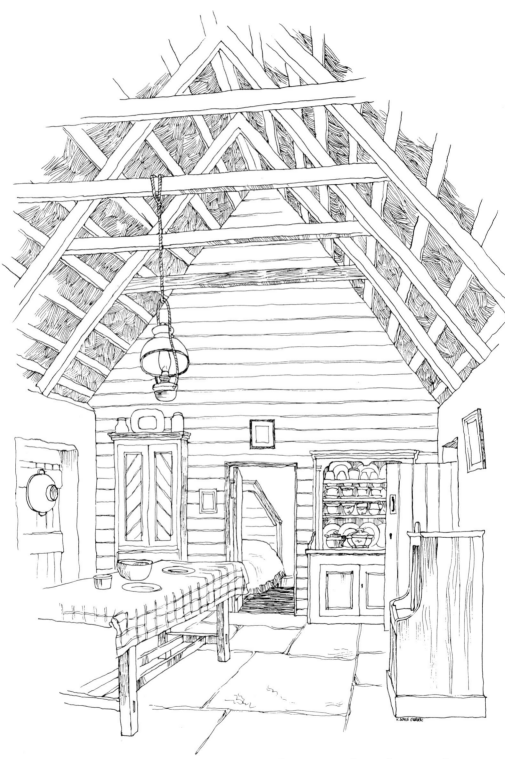

8. Inside the Loop Head farmhouse. The wooden partition has a dresser and press set into it.

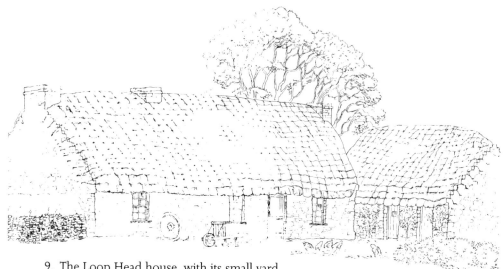

9. The Loop Head house, with its small yard.

time on the sea than on the land. Another source of income was the sale of turf cut and saved on the formerly extensive local bogs; this was carried up the Shannon in boats and sold in the riverside towns all the way to Limerick.

The fine four-poster bed in the upper room was made by a carpenter in County Kerry on the other side of the mouth of the Shannon. Formerly there was lively traffic across here as there was along most parts of the coast. A sailing boat could reach the Cashen in County Kerry in half an hour with a good wind, while the journey by land, through Limerick, would take at least two days.

The kitchen is separated from the lower bedroom by a wooden partition into which is incorporated a dresser and a press; this is a stage in the evolution from the ancient byre-dwelling form. A settle bed in the kitchen increases the sleeping accommodation.

The L-shaped pattern of the farmyard is typical of small holdings with only a few farm animals.

THE GOLDEN VALE FARMHOUSE

Here prosperity is evident at a first glance — this is the home of well-to-do people. This family would farm about 100 acres (50 hectares), with twenty cows and their calves, about ten dry cattle, six or eight pigs, two horses and a donkey, a large fowl yard with hens, ducks, turkeys and a couple of guinea fowl, and many pigeons. They would till ten or twelve acres, with wheat, oats, potatoes, mangels, turnips and, more recently sugar beet as

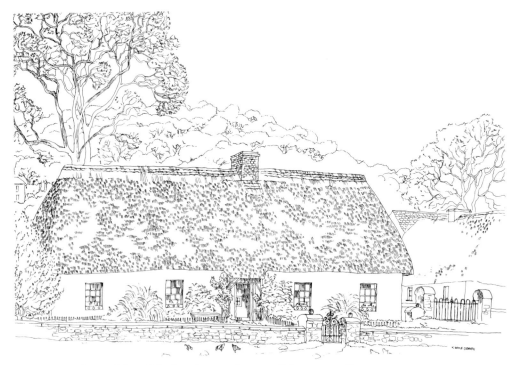

10. The Golden Vale farmhouse, home of the strong farmer.

well as several acres of meadow for hay. As well as the family they would have two or three servant girls and a servant boy, and employ two labourers permanently and others in spring and harvest. There was a kitchen garden with vegetables, herbs and flowers, and an orchard with a few hives of bees under the trees.

Inside the house you will notice the neat and practical lobby entry with the little window so that those at the hearth could see callers at the door. The kitchen floor is flagged but all the others are of wood. The wide open hearth has a useful crane and a wheel bellows.

Note the kitchen furniture, solid, handsome and adequate, and the stairs to the large attic bedroom – the servant girls' room. The servant boy slept in a loft over the stable. This kitchen was always a busy place, with work of all kinds going on during the day, and the circle of family, servants and guests around the fire in the evenings.

The parlour, with its furniture, fittings and ornaments, was something of a show place, as was also the best bedroom off the parlour. Lady guests were brought to the best bedroom to lay off their cloaks, bonnets and gloves, so that this room should reflect the status of the family in its fine furnishings. The two smaller bedrooms below the kitchen are more simply fitted out.

As well as being prosperous, this family would be well connected and prominent in local affairs.

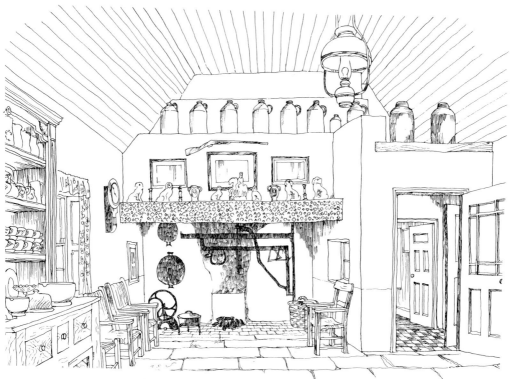

11. The comfortable kitchen of the large farmhouse with its entrance lobby and well-equipped kitchen.

THE *BOTHÁN SCÓIR*

This little dwelling of a poor labourer is in utter contrast to that of the rich farmer nearby. The farmer would let a small piece of ground, say half an acre (0.25 of a hectare), to the labourer, who would pay off the rent in labour, about eighty days in the year. For the rest of the time the labourer could work for himself or for wages.

The house is of the simplest kind, only one room with a bare hearth and a floor of packed earth. The simplicity of the furniture and of the few household goods speaks for itself. Their only livestock would be a few hens or ducks.

Such a labourer, if permanently employed on the same farm, would have some milk, vegetables and occasionally a piece of salt beef or bacon from the farmhouse, and his wife would also be employed there in the house or farmyard. Such a family would be well off among labourers. Most, it is to be feared, were less lucky. Note the hanging dresser, locally called a 'clevvy', and the chimney canopy made of mud-plastered hay-rope.

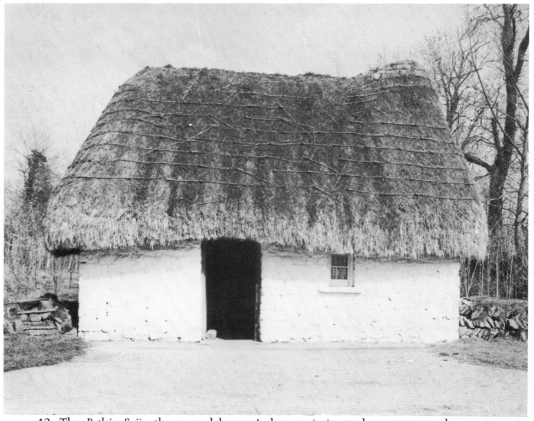

12. The *Bothán Scóir*, the poor labourer's house, is in stark contrast to the strong farmer's house.

THE BYRE DWELLING

This is a reconstruction of a type which has been known in north-western Europe since the Iron Age, in which the milking cows shared the house with the human occupants, and which survived in Ireland almost unchanged in a few remote districts up to the beginning of this century. The drain across the floor divided the cattle part from the rest of the house; it was usually strewn with turf dust to absorb the droppings of the cows, which with cattle fed entirely on grass and hay were not malodorous. This type of dwelling still survives in modified form in some areas of north-western Europe.

This house belonged to a subsistence economy where people's main concern was to produce for themselves the necessities of life, with a small surplus to sell to meet their few other requirements. Four milking cows, a few head of dry stock, a few sheep and a few hens, with small crops of oats and potatoes in the few acres of fertile land while the livestock roamed and grazed among bog, rock and heather.

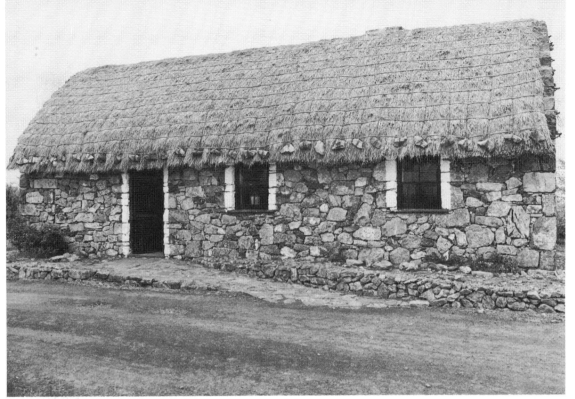

13. A type of house that has disappeared forever.

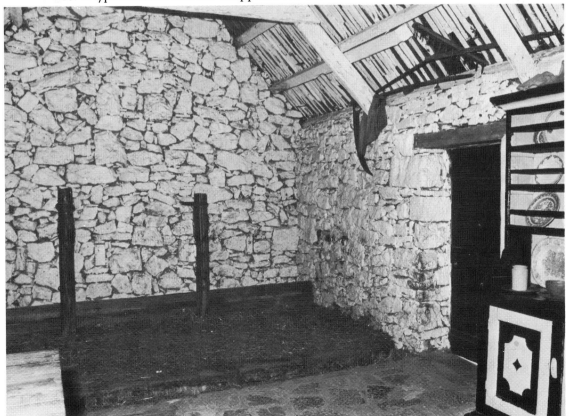

14. The Byre house in which people lived at one end and cows at the other.

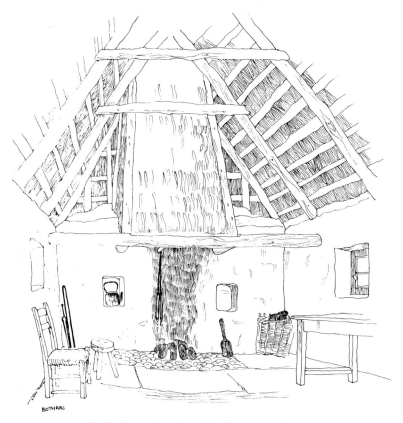

BOTHAN

15. The bare hearth of the labourer's house.

Note the open hearth with its stone hob seats and simple cooking utensils. Food might be plain and monotonous but was usually adequate and there always was plenty of turf for a good fire. (See illustration 27.)

On the left of the hearth you see the bed-outshot or *cùiltheach*, another ancient and widespread north-west European feature, which made a very comfortable sleeping place, usually reserved for granny or grandad who could rest comfortably there while still sharing the companionship of the group around the hearth. The bedroom is simplicity itself. Against the wall of the kitchen is a 'falling table' (see illustration 32) and stools rather than chairs provide seating. Many very old fashioned things are to be seen, the straw mats, the rushlight holders, the wooden tongs (*maide briste*), the goose-wing dusters, even the clothes hangers and the door handles and latches. Outside there are hardly any outbuildings, only huts for the hens and a pig. Most of the animals roamed free, even the cows were left outside except in the long cold winter nights. The rounded roof ridge, the rafter construction seen inside and the roped-down thatch tell of exposed location and strong winds.

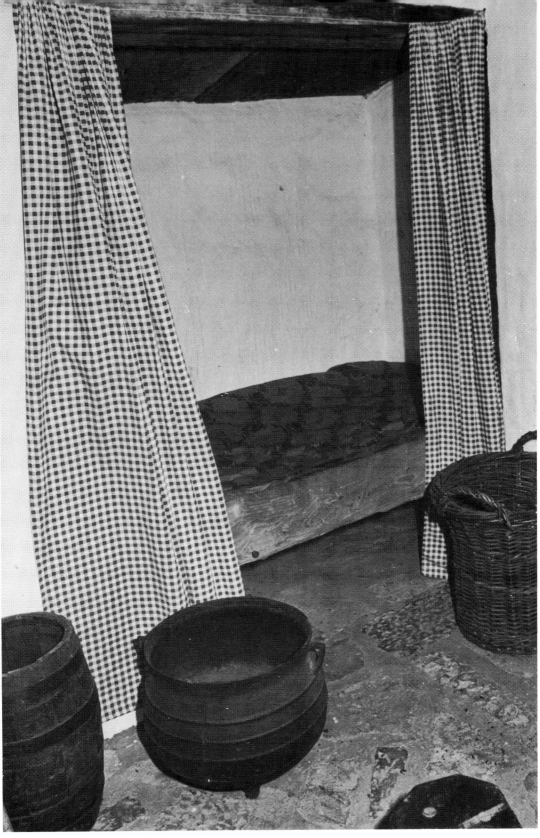

16. The outshot bed.

THE MOHER FARMSTEAD

> Stony seaboard, far and foreign,
> Stony hills poured over space,
> Stony outcrop of the Burren,
> Stones in every fetile place.
>
> JOHN BETJEMAN

Stone walls, stone roofs, stone floors show us a typical farmstead from the north of County Clare near the cliffs of Moher on the edge of the Burren. Note the massive beams needed to support all that weight of stone roof, and the well-wrought arch of cut stone over the hearth. And note how often stone is used where wood is used in other places, in lintels, shelves and benches. The dairy is a show place, so damp and cool in this dry landscape, and the well, in its own little house, gave a constant supply of cold, pure water.

Several kinds of fences, all neat and solid, surround the farmstead. One of these, of upright flagstones, shows how Cornelius O'Brien, one-time member of parliament for Clare, won a bet that he could build a fence 'a mile long, a yard high and an inch thick'. This holding was almost entirely a dairy farm, selling the butter in the nearby town. Thirty acres of pasture and meadow as well as common grazing supported fifteen dairy cows and their calves, and, as usual in County Clare, the housewife kept a large flock of geese as well as hens.

THE VILLAGE PEOPLE

The village stood half way between the town and the countryside, having some share in the life of each of them. The village people were as varied in social and economic status as the country people. Some were well off, some not. Some were respected and influential and others less so. And these two characteristics, of wealth on the one hand and good repute on the other were not necessarily bound together. A poor tradesman or a teacher retired on a small pension might be the person most regarded, while the rich merchant might have the name of being a rogue.

The most obvious people in the village were the shopkeepers, with their name boards and show windows. Then there were the tradesmen with their workshops, shoemaker, tailor, dressmaker, saddler, cooper, carpenter, blacksmith, candlemaker, printer, potter and others, to meet local demand. There were a few professional and official people, clergy, teachers, the doctor, the vet, the postmaster and the postman (usually

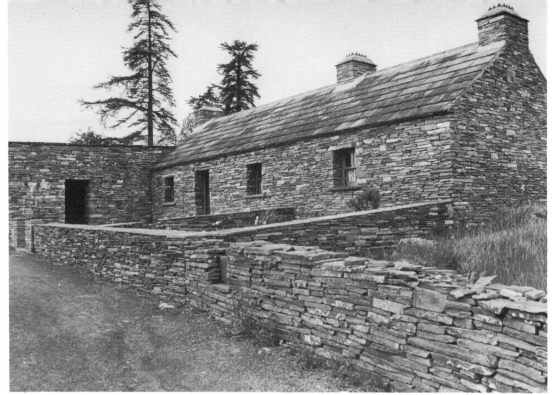

17. A good example of local materials in expert use, the Moher farmhouse.

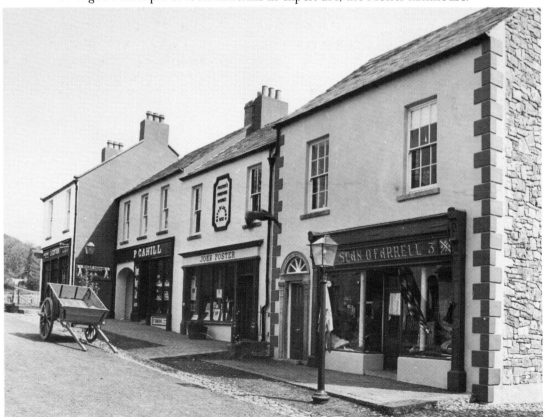

18. The village with its typical shops.

19. The village.

called postboy in those days) and perhaps a barrack of police. And, of course, work people, labourers, carters, yard men, domestic servants, shop assistants and so on.

All of these had a share in country life. Every household had a garden, and many had larger portions of land close by, with some crops or livestock. They knew their country neighbours, in fact everybody knew everybody else and everybody else's circumstances, and while the prying eye and the incessant gossip of the village were proverbial, nobody in village or countryside was likely to die hungry and unnoticed, as can and does happen in the town. The village people were essentially country people, often directly related to those who lived and worked on the land, and their lives, in their varying degrees of prosperity, were substantially the same. Their dwellings varied, just as did those of the farmers and fishermen and labourers. The shopkeepers usually lived over their shops. Some you entered through the shop, others, more pretentious had a 'hall door'. The tradesmen lived over or beside their workshops, and the others in large or small dwelling houses according to their status and means.

20. Pub and pawn shop flank each other – is there a lesson there?

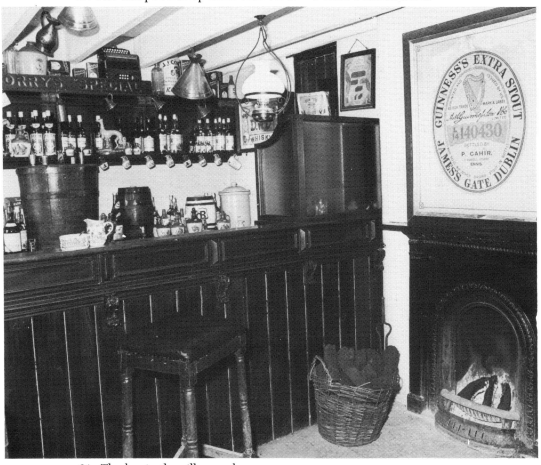

21. The bar in the village pub.

2.

The House

For most people the building of a new house is a serious matter, needing a lot of careful thinking. The family going to build a house must take all sorts of things into consideration, where to build it, for instance. A house occupies ground, and a yard or a garden is not to be despised. So, if the family owns the land, in what place should they build? And if they did not own land, were to buy or rent a site? Practical considerations were very important. The house should be convenient to the road and to the fields, in a sheltered place and near a water supply. The farmer must have room for sheds, byres and barns, and the craftsman for his working space and workshops. Every man and every family knew their own needs. But there were other considerations and other forces to be suited. There was the other world and its inhabitants. Sites of ancient human occupation or activity, such as prehistoric earthworks and stone monuments must be avoided, as they might be the abodes, or lie in the paths, of the Good People. Burial places, old or recent were likewise to be shunned; nobody would wittingly disturb the rest of those laid there. There was, of course, deep respect for the dead, but there also was the fear of what the rudely awakened spirits might do to those who had broken in upon their rest. In all this, people had to be doubly careful, as the presence of the unseen neighbours was not always and immediately obvious. There might be no surface indication of grave or habitation site. A usual way of settling this question was to set up four rods or four piles of stones at the four corners of the proposed site, and leave them all night. If they were still standing in the morning, all was well, and work could proceed, but if they had been thrown down or scattered, wise people moved slightly until they found a place undisturbed.

In the whole matter of house building, the hopes, needs, ambitions and resources of the family must be carefully balanced against each other. A nice house, but how nice a house can we afford? How big? We don't need a great mansion, but it must be as good as our neighbours. How much of the work can we do ourselves, and where must we hire expert craftsmen? And, first of all what materials and where to get them?

28

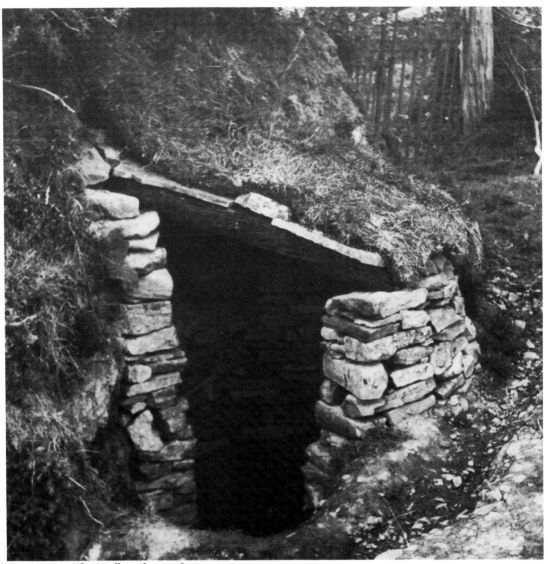

22. The well in the yard.

A characteristic of Irish traditional building materials is weight. Walls are thick and solid. Roof materials are bulky and heavy. And in former times before the coming of rapid and easy transport, local materials had to be used, as the cost and labour of bringing heavy loads over long distances meant that people had to take the materials which were within their reach, whatever was provided by the locality.

The type and quality of local materials can vary significantly from place to place. Some are easy to handle and use, some difficult. Some can be used by any handy man, others need the skill of the trained craftsman. Some are not suitable for certain constructional features, for instance arches, often to the extent of causing a traditional absence of such

features. This variety of materials gave rise to local styles and methods which were very evident as one moved across the country. Good builders were very conscious of the outward appearance of their work and took care to improve and enhance it, while the use of purely local materials always ensured that the finished structure fitted smoothly into its environment, and did not shock it or do violence, as do some misguided efforts of 'modern' fashion in building.

Local climate is another important environmental factor. Our climate can be damp and rainy, hence sloping roofs and well plastered and limewashed walls. It can vary rapidly from warm to cool, hence thick walls and roof covering. It is hardly ever bitterly cold, hence the traditional hearth forms. And so on.

When the foundations were laid, and the proper symbol or whatever was demanded by local custom deposited under the foundation stone, the walls begin to rise.

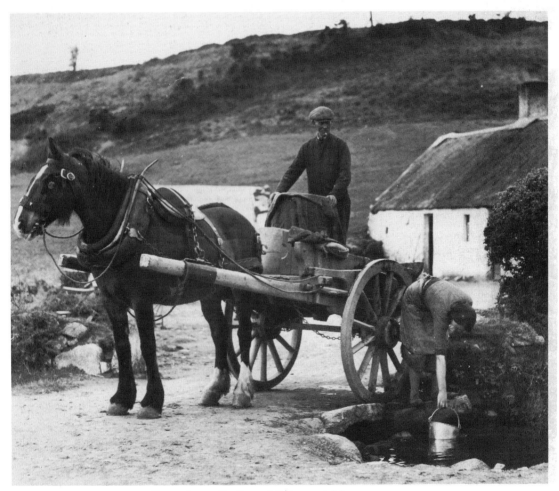

23. Drawing water from the well of an obliging neighbour.

24. Well laid masonry; a roof of heavy slate and flagged yard, all typical of north Co. Clare.

25. Expert stone-laying in the out-buildings of the Moher house.

Irish tradition demands thick walls of solid material, which support the whole structure and form the outer skin against the elements. We can contrast this with some traditional methods in other countries which use a framework of heavy timber with an infill or cover of lighter material.

In Ireland the most usual wall material was stone, bedded and pointed with mortar of sand-and-lime, or clay-and-lime. In many places, especially in the midlands and the south-east, where suitable stone was hard to find, the technique of building walls of clay – well known in many other parts of Europe – was perfected, and some of our finest farmhouses were built of this material. There were other districts, mainly near the west coast, where neither lime nor suitable clay could be found, and here the art of building 'dry walls', that is stonework without any binding material, was well known. On bog and moorland, where no other material could be found, good solid walls were constructed of sod, that is to say, the grassy or heathery surface of the ground cut in blocks perhaps two feet square and six inches thick – a tough material bound as it was by matted plant roots.

Where flagstone could be found or bought, kitchen floors of these were laid, with wooden floors in bedrooms. Poorer people or those in less favoured areas made do with floors of rammed clay, which were very good in dry weather but softened and became uneven in damp weather. People with more wealth or pretension had floors of brick or tiles.

Timber presented a problem. The destruction of the extensive wood-lands in the sixteenth and seventeenth centuries left a timber famine. People who lived near bogs could find 'bog timber', hidden and preserved under the peat, great trunks of pine and oak, straight and strong, easy to work, almost impervious to the attacks of damp, insects and fungus. Many houses were finely roofed, floored and furnished with 'bog-deal'.

Imported timber could be and was bought and most houses were fitted and furnished with wood from Scandinavia or Russia or Canada. But poorer people such as cottiers and labourers had to be content with any scraps they could obtain and many of their houses were very small for lack of beams of wider span.

As to the roof covering – this depended upon what choice of material was provided by the locality, and, like all else, on how much time, labour or money could be spent on it. As always, the poorer man had to be content with less than the more prosperous. A farmer could have plenty of good straw from his wheat or oats, while a landless labourer might have to do with rushes. In wilder places which grew little or no grain, there was sedge or coarse grass, and near river and lake there was reed. Some districts had good quarries of slab or slate, sound roofing material, although not as warm as thatch. While the forests survived, there were shingles, thin plates of wood, good covering when coated with tar.

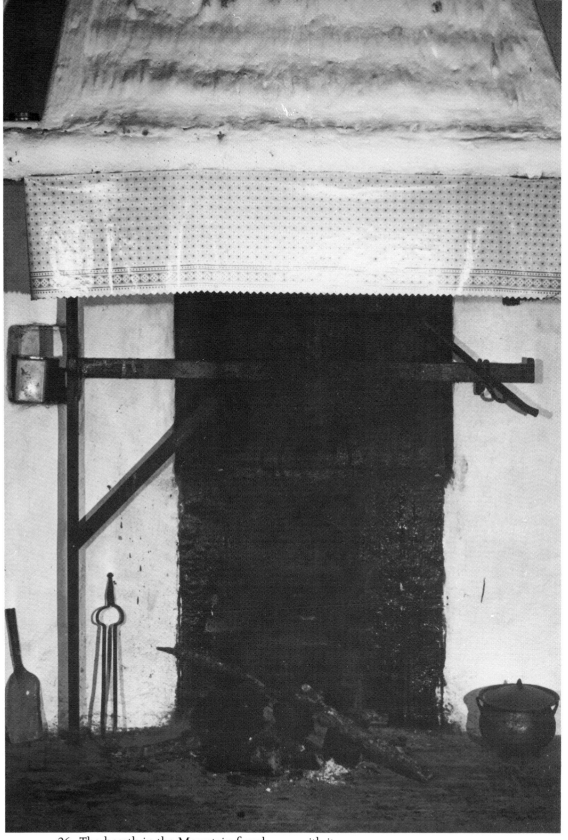

26. The hearth in the Mountain farmhouse with its crane.

3

Inside the House

Which comes first, the chicken or the egg? As regards our traditional economy the question can be put – was it our social and domestic custom that demanded an open hearth at floor level, or was it the open hearth that formed our social and domestic custom? Or was it the interplay of both? Whatever the answer, the fact remains that the open hearth and its tradition is part of our conscious make up. We sit facing the hearth, even in suburban drawing rooms when the summer evening is too warm for a fire. A misguided person who turned his chair around and sat with his back to the fireplace, even when empty, was regarded as an untimely joker or as not being 'all there'. To us the table is for some activity, household work, eating, writing, card playing. Talk around a table is serious matter – conference or committee, future planning or industrial relations. To sit around a table in casual, social conversation, as some of our European neighbours do, is foreign to us, slightly uneasy, wondering what is coming on the table, not at all relaxed. And as to our eating habits, the old Irish proverb *Nua gacha bídh* – 'the freshest of every food' means each meal, indeed each dish, cooked separately in a small utensil not in a great oven, as in other traditions. Cold food as second best, bread baked freshly every day, a dislike of 'left-overs' are all part of our tradition of the open hearth.

Of course, most parts of Ireland had turf in abundance, and poor indeed were those who did not have access to it. It cost hard labour in cutting and harvesting, but for many of us the days spent 'footing' and 'drawing out' in the turf bog are very happy memories. In older times there was plenty of firewood to be had. Both of these fuels, turf and wood, burn easily and well in a fireplace at ground level, and it is significant that it is in these eastern districts where turf was scarce and the woodlands cut away that coal came into use as a domestic fuel, and led to the modification of the old ground level hearths with barred grates, wheel bellows and enclosed ovens.

Cooking utensils were either hung or propped on a stand over the burning fire. Most hearths had a 'crane', an upright pivoted member, with

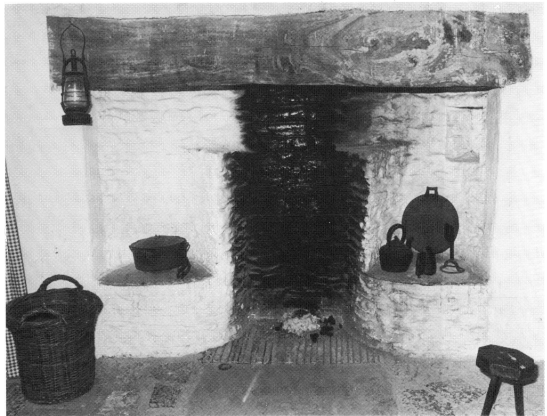

27. The hearth of the Byre dwelling with stone seats on each side.

an extending arm from which the utensils could be hung. Many of these were ingenious contraptions which allowed the utensils to be raised and lowered at will or had provision for two or three utensils at the same time. Poorer hearths had more simple pot hangers. Besides, there were various trivets and other stands, raised on feet five or six inches high on which the pot or pan rested with glowing embers underneath.

The main utensil was the three-legged pot, made of cast iron. These varied in size and capacity from little ones that held a gallon to monsters that encompassed twenty gallons or more. Most houses had several of these, for various uses. Smaller ones boiled the family's food, larger ones heated water for washing or cooked food for the animals.

There were flat-bottomed three-legged pans for baking and roasting. The careful housewife had one of these for baking bread, and never used it for anything else; this 'pot-oven' or 'bastable' was never greased, but sprinkled with flour or meal to keep the bread from sticking. Another pot oven of similar shape and size was used for roasting fowl or joints of meat, or for baking apple tarts; this was greased with lard or bacon-rind or, in extravagant mood, butter.

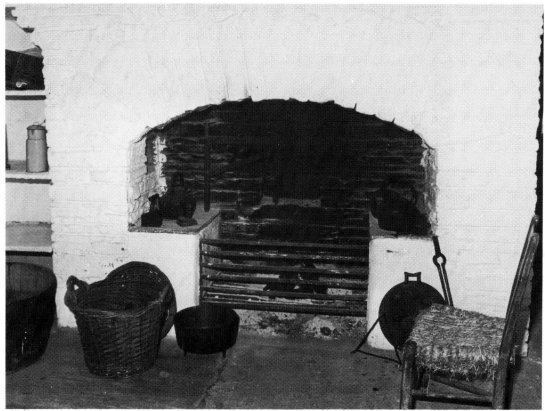

28. The typical Burren hearth with its stone arch. Note the flagged floor and shelves of stone slab.

Smaller pots, known as 'mullers' or 'skillets', flat bottomed with long handles, were used for cooking small quantities of food or for heating drinks; they were set on a trivet or directly on a small heap of glowing coals. Cast iron frying pans, of various sizes, were similarly used.

In some houses meat was roasted on a spit. The spit was a bar of iron about four feet long, with a crank at one end, flattened in the middle part and rounded towards each end. This spit was thrust through the piece of meat, laid across the hooks and, as the meat cooked, the spit was turned by means of the crank so that each side was presented to the fire, while a dish or pan underneath caught the dripping juices.

A couple of griddles of different sizes served to bake flat bread and scones, and sometimes pancakes, although these were more usually made in a long-handled frying pan so that they could be tossed. The frying pan was of course used for all the usual frying. In the areas where oatcakes were eaten there always was an oatcake stand made of iron, stone or wood. A salt-box hung close to the hearth, for salt must be kept dry

There were some fire irons, usually a pair of tongs and a hearth shovel,

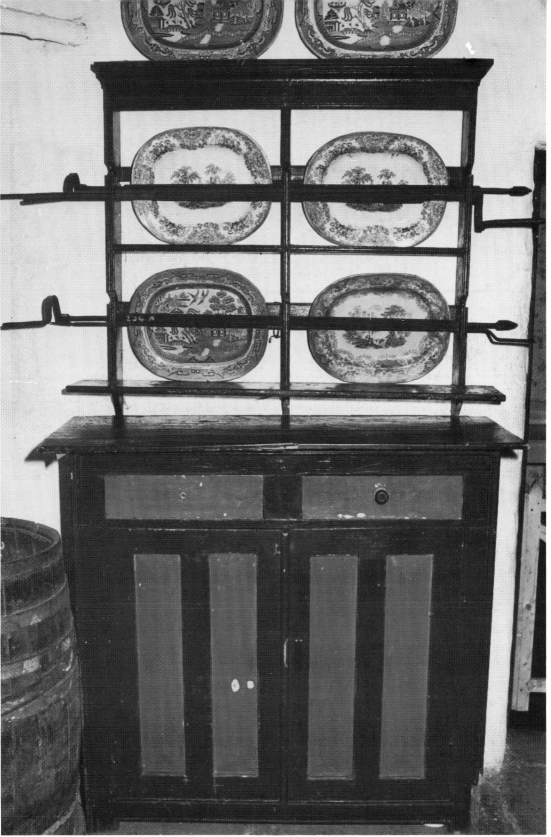

29. The spit dresser.

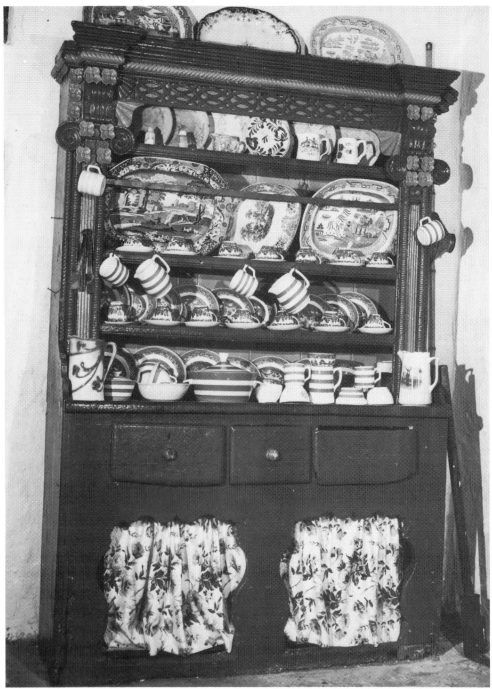

30. A dresser filled with shining delph, speckled and white and blue and brown.

the latter often a worn-down farm shovel. Some poor houses had a *maide briste*, a bow of stout wooden twig instead of a tongs made by the smith. There were pot-hooks and lid-lifters with which to manage the utensils, as well as brooms, besoms and dusters.

About two hundred and fifty years ago iron ranges began to appear, first in the 'big houses' of the gentry and later in the houses of farmers, tradesmen, villagers and so on, in some cases taking the place of the open hearth and in others supplementing it. Now the process of change is almost complete, with the spread of modern ranges and stoves and the virtual disappearance of the open kitchen hearth. Still, the sight of people sitting around a stove with no visible spark of fire seems not quite natural. Something is missing. Is this mere nostalgia or some deeper psychological need in a people whose ancestors throughout the length of human history sat around open fires? Is this the fascination of the camp fire and the barbecue?

Solid simplicity was the keynote of the kitchen furniture. A big dresser stood against one wall, loaded in the open upper part with china and earthenware cups, saucers, plates and dishes. Up to a century or so ago, milk, tea and other beverages were drunk from large bowls which held a pint or so, and some old dressers still have rows of these. Some jam makers sold their products in brightly patterned china jugs, some of which still grace the dresser. But the centerpiece always is one – or several – large dishes, willow pattern more often than not. Many kitchens had a 'clevvy', which was a shallow hanging dresser with an array of pegs or hooks on which cups, mugs and jugs were hung by their handles, and some houses still have a spit dresser, the side uprights of which had deep notches to hold three or four spits, with three or four large meat dishes standing behind the spits.

A flour bin stood against a wall, a tall chest with a sloping lid divided inside into, usually, two, sometimes three compartments to hold different kinds of flour and meal for bread-making, and a shelf on which stood the bread soda in a jam jar, the tin of baking powder, a flour scoop and a sieve. Some housewives kept the 'losset', the small wooden trough in which the bread was kneaded, in the flour bin, others in the closed lower part of the big dresser, which also held large jugs, buckets, pots and pans and other 'clean ware'.

The lower part of some old fashioned dressers was a coop for hatching hens.

There was a large table but this did not stand in the middle of the floor as one might expect but was pushed to one side when not in use for working or eating or playing cards. Often there was another table, a small one, used by a woman sewing or a child doing homework; this table stood under a window, on the inside sill of which stood the household's pen, ink and writing paper. Formerly pens and ink were home made, pens from the quills of geese or other birds – the smaller the bird the finer the pen – and ink from a blend of oak galls, iron rust in water and a

31. Another form of dresser. Above a rack of plates and dishes, below a coop for hatching fowl.

trace of glue. Paper had to be bought and so used sparingly. The children learned to write and figure on slates which could be cleaned off.

Some houses had a 'falling table', a useful device which folded up against the wall when not in use. This was usually supplementary to the big kitchen table, but in some smaller houses it was the only table.

It may sound very odd indeed, but the fact is that until quite recently, into this century, there were some small houses, here and there in remote areas, which had neither tables nor chairs. Stools, small three-legged ones or long 'forms' with four legs took the place of chairs and, indeed, were commonly used even in houses which had lots of chairs. As to the tables, there was an old and useful contrivance which served as a table at meal times. The large iron pot, full of hot water was placed in the middle of the floor, with a large round flat basket with a shallow rim laid on top of the pot. The bowls and dishes containing the food were set out in the basket and were kept warm by the rising steam. This served as the only table in some houses, although it was often used in houses with one

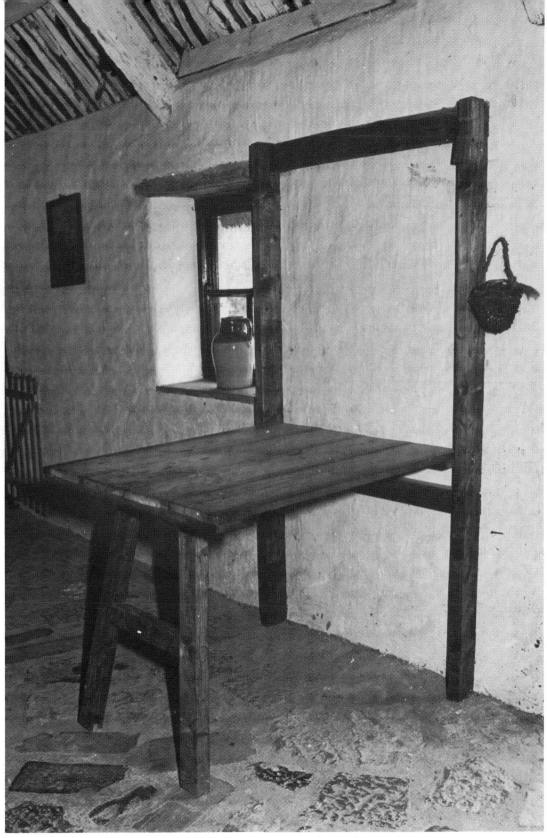

32. The 'falling table'.

or more tables. Can this be the origin of the *bain-marie*?

Chairs, like the tables, were ranged by the wall. Indeed a characteristic of an Irish farmhouse kitchen was that the floor space was free and uncluttered in the middle. Kitchen chairs, usually *súgán* or rope seated, were made by the local carpenter, as indeed was most of the furniture in the house. A couple of *súgán* armchairs, one on each side of the hearth were private to the woman-of-the-house and the man-of-the-house; it was the height of discourtesy for anyone else to sit in one of these without being bidden to do so. In an old-fashioned hearth there was a 'keeping-hole' on each side, a small recess, with the small personal belongings of the person who sat on that side, a pipe, a snuff box, tobacco, a pair of spectacles. We must remember that older women commonly smoked pipes in the past. It was an honour to be offered a smoke from one of these pipes or a pinch of snuff from the private box. Most visitors were asked to draw up a chair to the hearth, not to sit in one of the owners' chairs.

A strong wooden stool, or a stone slab in some cases, stood near the back door and supported a couple of buckets of clean water for drinking, cooking and making tea. Water supply was, as we have seen, an important consideration in siting a house. A good spring well, in many cases fitted with a pump or a spout should be near the house, and a small stream running through or near the farmyard was essential to household and farm work.

In many houses a shelf over the hearth held some of the family treasures, a pair of brass candlesticks, or of china dogs, or a crucifix. Sometimes you would find a large rosary beads hanging on a peg near the hearth, and in most kitchens a religious picture in front of which a little red lamp always burned. The Saint Brighid's Cross and the sprig of Palm Sunday palm were in evidence too.

Bedrooms were simply furnished. Besides the bed or beds the room usually had a washstand, simply made by the local carpenter. A curtained alcove served as a wardrobe where there was no cupboard, but the more prosperous home had wardrobes and cupboards in the bedrooms. More old-fashioned people kept their clothes and linen in wooden chests with tight fitting lids to defeat the clothes moth, which was further discouraged by sprigs of lavender, bog-myrtle or other aromatic plants strewn among the clothes.

Beds came in some variety. There were quite plain divan-like beds and beds with low wooden heads and ends. There was the 'covered-car' bed set against the wall and solidly framed in wooden boards at back, top and ends, with a curtain across the front. There were 'four posters' which stood in the middle of the floor, usually with heavy curtains all round

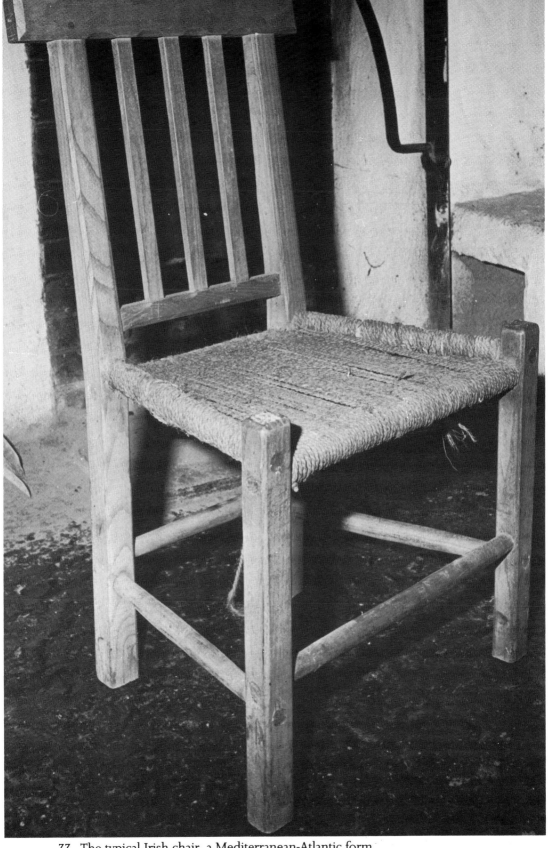

33. The typical Irish chair, a Mediterranean-Atlantic form.

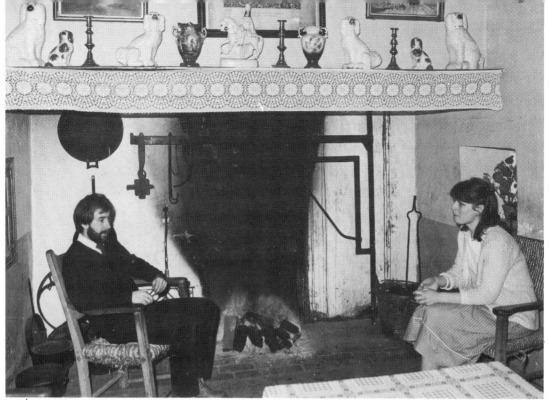

34. Shelf over the hearth displaying family treasures.

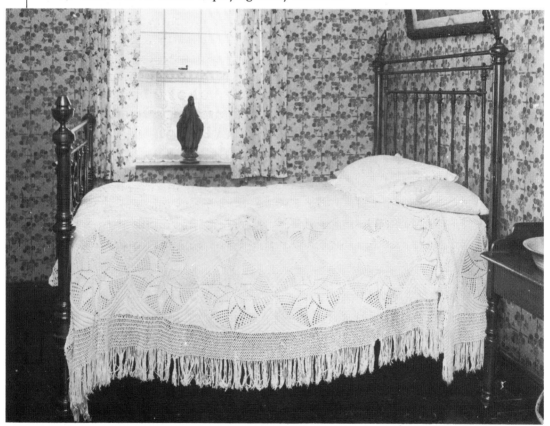

35. The height of fashion in 1900 – the brass bedstead.

and a cloth roof. Some rooms boasted of iron bedsteads with brass or even china knobs and fittings. These modern contraptions had wire mattresses, but the older beds had either a plank floor or a crisscross of ropes skilfully twisted from bog deal to support first a thick straw mattress and then a feather 'tick'. Bed clothes were home made or locally made in all the best houses, with hand spun and woven linen sheets, pillow slips and bolster covers and woollen blankets. Quilts and bedspreads were often showpieces, woven, crocheted, knitted or patchwork. On the floor were mats and rugs of ragwork or animal skins – sheep, goat or calf, sometimes fox or badger. A few pictures, usually of religious themes, on the walls and a brightly patterned set of wash-basin, water-ewer, soap-dish and chamber-pot finished the picture.

There also were supplementary or emergency beds in most houses. In kitchen, parlour or bedroom there was sure to be a 'settle bed' which folded up into a wooden bench during the day or a 'press bed' which resembled a sideboard when closed. In south-west Munster a large wooden bench like a garden seat stood on one side near the kitchen hearth, and could make a welcome, if rather hard, bed for the benighted traveller. That notable feature, the outshot or bed alcove was found in most houses in the north-west. It was formed by projecting a section of the side wall of the house near the hearth outwards to form an alcove measuring in plan about six feet by three feet – the depth varied. This was closed by a curtain and contained a bed, which was especially favoured by an old granny or grandad who might be bedridden but were loath to leave the good company about the hearth in the evening, and could happily join in the conversation and contribute to the output of *seanchas* and storytelling.

Most houses had one or more attics, usually called 'lofts'. One or other of these might be an extra sleeping space, and in larger houses were regular well furnished bedrooms. But at least one loft served as a store room for goods not in use and might be a treasure room of by-gone gear, with an old cradle, a spinning wheel, old chests, a hank winder and fifty other relics of the past.

In the eighteenth century first the larger, and then, as the fashion spread, the smaller houses of the countryside began to set aside a room for the entertainment of important visitors, called the 'parlour' (the talking-room) or, more pretentiously the 'drawing room' (the withdrawing room); our grandparents would not know the term 'front room', which is a product of the city streets, and would scorn to use 'lounge'. The parlour was seldom used by the family, whose living room was the kitchen, but the visitor considered special was incarcerated there, and entertained by members of the family taking turns one by one. As in

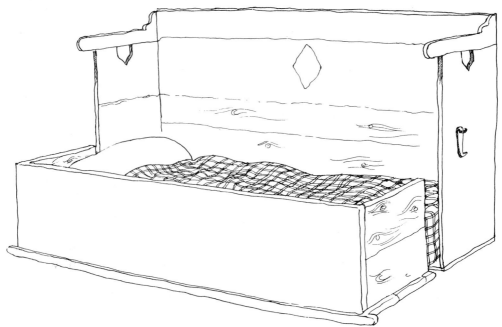

36. The settle bed which folded up to make a seat bench.

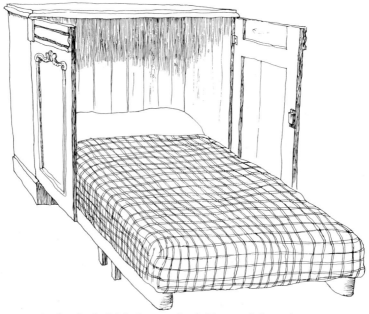

37. The 'press bed' which folded up to look like a sideboard.

so many other things this was a recognised convention. The visitor who was an intimate friend was treated as a member of the family and could join in discussion and argument around the kitchen hearth while the stranger or the official was kept to the parlour, which was usually lonely and often damp or stuffy from disuse.

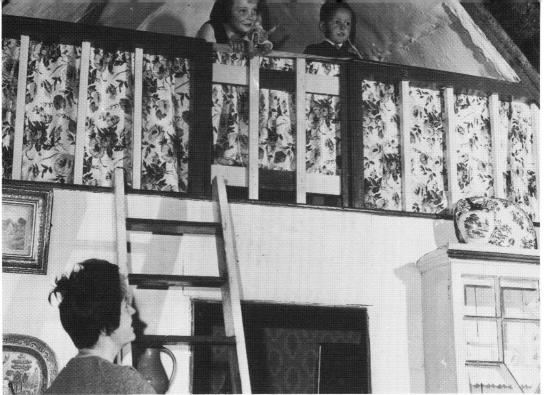

38. The children, in the bed loft, were still part of the company in the kitchen.

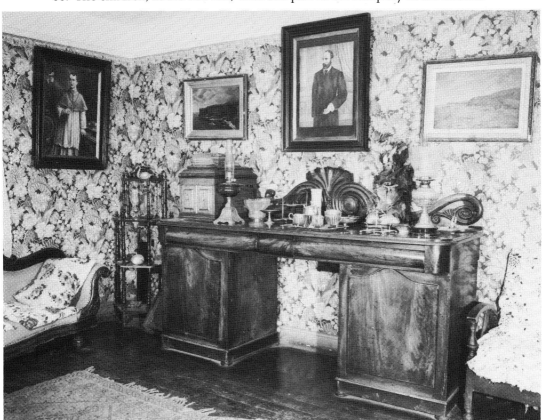

39. The parlour of the Golden Vale farmhouse.

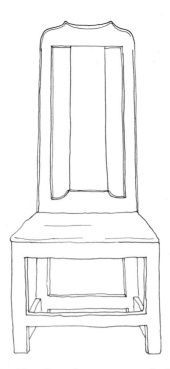

40. Much parlour furniture, like this chair, was made by local craftsmen on the model of fashionable styles.

The parlour had to be furnished after the fashion of the moment, that is to say the moment when it was set up – usually in the Victorian era, with, of course, later accretions of furniture and ornament. Pictures of a non-religious kind, with family photographs filled the walls, the 'Monarch of the Glen' vieing for notice with the studio photograph of the wedding of an American cousin. The walls themselves were sure to be papered, and the furniture heavy mahogany and horsehair, probably with antimacassars on the chairs and a plush cloth with bobbles covering the table, which, with the chiffonier, the whatnot and the overmantel, overflowed with ornaments, knicknacks and trifles of all kinds from stuffed birds to brass monkeys, photograph albums, a bioscope, a gramophone with a horn, several presents from seaside resorts, and, since we are a wandering people, mementoes and souvenirs from almost any corner of the globe. A piano in the parlour was a definite status symbol, as much as a daughter or two away at boarding school or an uncle a missionary bishop.

The parlour was sure to have several oil lamps. It is a very remarkable fact that from early Egyptian to late Victorian times there was no appreciable improvement in the provision of artificial light. The rushlight,

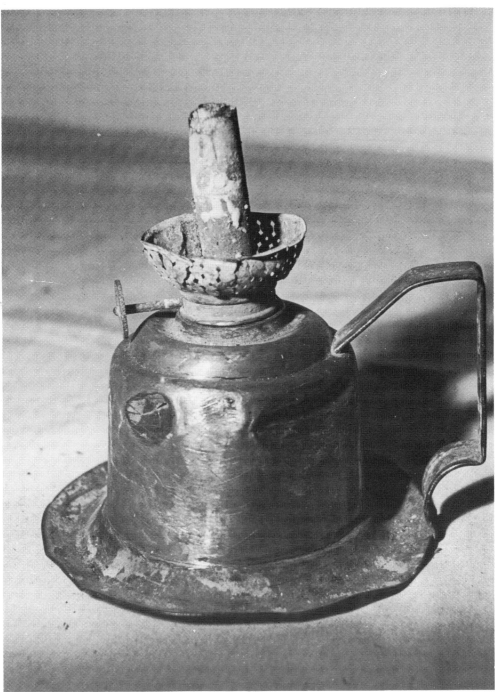

41. An early form of oil lamp.

the candle and the oil-lamp were the best they could do. Dante wrote his great poem, Paré conducted his medical experiments and Newton explored the great scientific principles by the light of lamps and candles

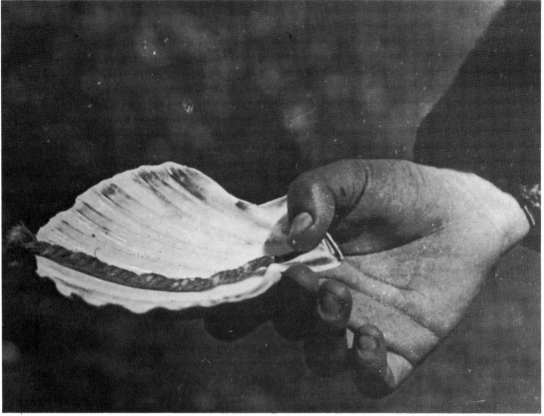

42. A scallop shell full of fish oil, with a wick made with a string, made a simple lamp for seacoast dwellers.

no better then those which illumined the work of Cicero or Archimedes.

Up to the middle of the last century, and in many cases later, most people in the countryside provided their own lighting. A bundle of bog-deal slips, kept near the hearth, provided a quick source of light. Rushlights were made by partly peeling rushes so that a strip of skin kept the pith together and, when these had dried, dipping them in melted wax or tallow to make long thin tapers which gave as much light as an ordinary candle. In use a rushlight was gripped in a pliers-like holder fixed in a stand, Candles were made by the repeated dipping of a wick into melted wax or tallow, allowing each coat to harden before dipping again. Usually a number of wicks hanging from a frame were dipped at the same time. These were called, as one might expect, dip candles. A more finished if no more efficient candle was made in a mould, a tube of suitable size, one end closed usually in conical form with a hole in the middle through which the wick was threaded. The mould was then filled with the melted wax or tallow and dipped into cold water to speed up the hardening. Often a dozen or so moulds were fixed in a frame, and of

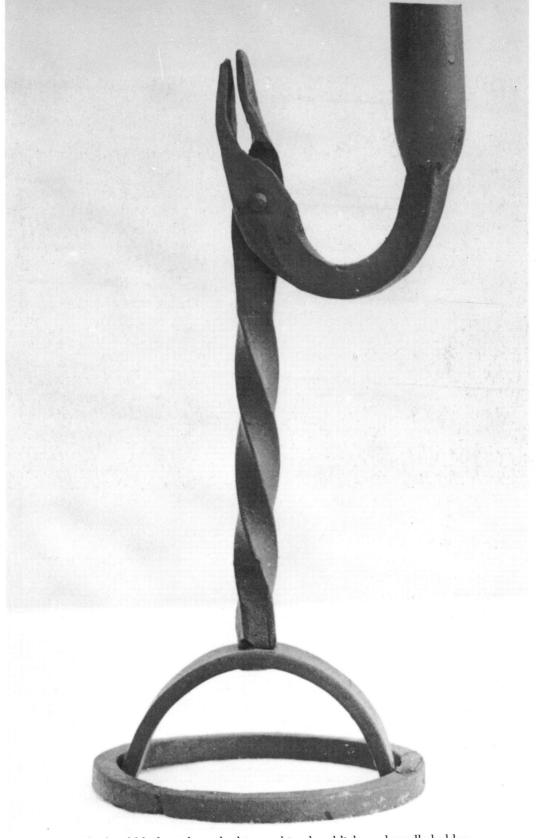

43. The local blacksmith made this combined rushlight and candle holder.

course there were different sizes of mould for different sizes of candles. Those who kept bees, and many did, saved the beeswax for candle making, and especially for the candle used on special or religious occasions. Burning beeswax has a sweet smell, while the smell of the cheaper tallow candles varied from the commonplace to the almost unbearable.

Until the eighteenth century lamps were of the crudest kind, merely a bowl of animal or vegetable oil with a projecting or floating wick. The sanctuary lamps in our churches are survivals of this type. In household use the bowl of the lamp might be an iron cresset, a little basin carved from stone, an earthenware dish or a large sea shell, and the wick a piece of string or a wisp of moss. Tinkers made a lamp like a small teapot out of sheet iron, with a handle on one side and a spout on the other to hold the wick.

The coming of, first, whale oil, and later, petroleum and paraffin led to the development of better and better oil lamps up to the incandescent mantle paraffin lamps of the nineteen twenties which gave a light that was both brilliant and easy on the eyes. In between these and the first oil lamps was a long series of all sorts of shapes and sizes and all degrees of ornamentation, which were favourite and welcome wedding presents.

44. The candle-maker at work.

4

Food

In common with so much else, houses, clothes, transport and so on, a family's daily diet depended chiefly on the family's economic status. Of course, many foods familiar to us now were quite unknown, yet the people of one or two centuries ago were better informed in food matters than we might suspect. Amhlaoibh Ó Súilleabháin, a schoolmaster in County Kilkenny, kept a diary in the eighteen twenties and eighteen thirties in which he mentions dinners at which he had baked trout, smoked salmon, asparagus in cream, cherries, white wine and other delicacies. Many farmers' wives liked to put their young daughters for a year or two in 'good service' as maids in the 'big house' or in the house of the teacher or the doctor, where they would learn about cooking, fine linen, table setting and other refinements. On the other hand, there were poor people who felt lucky to have a scrap of meat once a week to relieve a diet of potatoes, porridge and bread and tea. But most people normally had enough to eat and some dainties or luxuries at least from time to time. How often depended on circumstances; we might say that the gentry's everyday dinner was the farmer's Sunday dinner and the poor man's Christmas dinner.

From the huge quantities of bones found in the excavation of ancient and medieval Irish dwellings it is quite clear that meat was a major element in diet. Meat continues to be regarded as the 'best' food down to our own time. A main meal without meat (except on fast days) was inadequate, certainly not to be offered to a guest.

Down to the end of the last century most farmers of any substance killed a bullock or an old cow at least once a year. Pigs and sheep were likewise killed. Some parts of the carcass, such as heart, liver, kidneys and 'trimmings' were eaten fresh. It was the custom on killing any beast to send fresh portions to the neighbours, who responded in kind at their killing. With six or eight households thus exchanging gifts, each had fresh meat to eat on numerous occasions. The blood and entrails provided blood puddings which were spread around like the fresh meat. The unwanted male young of cattle and goats provided veal and kid, always

54

eaten fresh, and nearly always roasted.

The meat to be preserved was salted or smoked. Most was salted down in barrels; a small quantity of saltpetre added to the salt. After three or four weeks in the barrel the flitches of beef or bacon were hung up on the 'meat stick' – a stout beam which ran across the kitchen and was arrayed with many iron hooks. The inevitable overspill of turf smoke from the open hearth gave the hung meat a special flavour. Some portions might get finer treatment. Hams might be cured with sugar or smoked over wood shavings or sawdust. In some mountain districts sheep were killed and some of the mutton salted or smoked, but the killing of pigs at home became more common as the home killing of beef animals grew less common, so that, by the twenties and thirties of this century almost every rural household killed at least one pig a year. Pig killing was a lively and rather complicated business. The animal should be killed quickly and as far as possible painlessly. Once dead the blood was drawn in a large pan, salt added and the mixture stirred vigorously. The pig was not skinned, as was done in other countries, but the bristles were shaved off cleanly by sharp blades aided by copious applications of hot water. Indeed, a constant supply of hot water was absolutely necessary as a lot of washing and rinsing had to be done.

The women had their part in the process, and the men theirs. The actual killing, blood drawing, shaving, drawing and cutting up was done by the men. The washed, cleaned and gutted carcass was split in two and the back bone was cut out. In an average bacon pig of one and a half to two hundredweights, each half of the carcass was cut into seven main pieces, shoulder, ham, three back pieces, belly and half head. All of these might be salted, but often the head and hams were treated specially. In salting, each piece was well rubbed with the salt-saltpetre mixture, and the pieces were packed into a barrel with more salt. This was part of the men's work. Meanwhile the women were equally or even more busy, dealing with the other parts of the animal. The lower legs and feet – the crúibíní, the heart, liver, and kidneys, and the ribs and other bones which had been cut out of the flitches were cooked fresh or very lightly salted. The pork steaks or gríscíní, the equivalent of the fillet in beef, were removed in one piece from each side; these were the greatest delicacy and always eaten fresh. Another delicacy was the pig's tail, always demanded by the children. The hams might be laid for some days in a blend of salt, saltpetre and brown sugar and then smoked – the usual smoking chamber was an old barrel with the ends removed; this was upended over a rough fireplace of stones, the hams hung inside, the barrel partially covered to trap the smoke, and a small fire of wood chips, sawdust, turf or a mixture of these lit underneath and kept smouldering.

There were arguments about the tastes given by different fuels; oak sawdust was the best, it was held, but some went so far as to prefer the smoke of damp straw or hay, and a few, more daring, added fragrant wild herbs to the fire. The head might be made into brawn. First it was 'boiled to rags' in the least quantity of water, then the meat was pulled from the bone and, including the ears, chopped finely, seasoning and herbs added to individual taste, and the whole mixture pressed into bowls and left to cool and set. The tongue, eaten fresh was another special delicacy.

All of this was nothing to the bustle and the mystique of black pudding making. To the salted and defibrinated blood (this latter achieved by vigorous stirring or whipping of the fresh blood) was added chopped fat of the pig – about a cupful to each quart of blood. This was thickened to a loose paste by adding oatmeal, and the whole well flavoured with salt, pepper and herbs, usually thyme. Meanwhile the intestines were carefully cleansed, scraped and washed, and cut into lengths of about eighteen inches. One end was tied off and the length filled with the mixture – loosely, because it swelled in the cooking – and tied in a circle. The puddings were then boiled for about half an hour.

Then came the parcelling out. Appropriate portions of the black puddings, pork steaks and fresh bones were sorted out, and parcelled up to be sent to the circle of neighbours. Delivering the parcels was the children's privilege – they usually got a little present in return. Another children's perquisite from pig-killing was the bladder. One of the men washed this, blew it tightly full of air, tied it off and gave it to the children who used it as a football. With care it might last several weeks in play.

Sausages were hardly ever made. This was probably because one animal did not provide enough casings for the available blood mixture – the surplus was in some places filled into the prepared stomach like a haggis, or cooked in a bowl or a pan for immediate eating. Sausages were rare in the countryside. Indeed the tale ran of the simpleton who, after his first attempt at cooking them was heard to remark that 'by the time they were gutted and cleaned, there wasn't much left!'

Every countrywoman kept fowl – hens, ducks, geese and turkeys, and sometimes guinea fowl. These not only provided meat and eggs for the household but also made ready sale at the market or with the local dealer, and an industrious woman or girl could make a considerable income from it. Even quite small girls had their couple of laying hens or clutches of chickens to care for and rear. And how proudly they went with their mother to sell their produce, and buy sweets or hair ribbons with the profit, or save it up for some special purchase! This commerce in fowl and eggs was entirely the women's business. No man of decent feeling

45. Fish drying on a wall.

would interfere in it, still less expect to get any of the women's well-earned money. Up to the middle of the nineteenth century pigeons were commonly kept and a dovecote may still be seen in many a barn gable.

Fish was eaten more commonly a century ago than it is today. Along the sea coast it was a constant form of diet, and great quantities of preserved fish were sold inland – mostly salt or smoked herrings, but also dried ling, cod and similar fish. The custom of abstaining from animal products during Lent and on Fridays increased the consumption of fish, which was allowed. Along the coast, the fish diet was more varied, with many kinds of fish caught on lines, and many kinds of shellfish. Three kinds of seaweed were eaten, as occasional delicacies rather than as important food; these were *dilisc* – 'saygrass' (Rhodymenia palmata) which was dried and chewed raw, *sleamhchán* – sloke or sea-lettuce (Ulva) which was boiled and eaten with meat, and *cairigín* – 'Irish moss' (Chondrus crispus) which was bleached in the sun, then boiled in milk to make jelly. Some other kinds were eaten as famine foods.

Near rivers and lakes some freshwater fish was eaten but seldom was important as a food supply. As may be expected, salmon and trout were considered best, but pike, bream, perch and several others were not unwelcome. Curiously, one fish widely eaten in other countries was rejected in most parts of Ireland, the common eel.

Wild game was welcomed. Ducks, geese, grouse, pheasant and partridge, snipe and woodcock fell to the shotgun or less legitimately to various cunning traps and snares. Of course, most landlords claimed exclusive shooting and fishing rights over their tenant's land as well as their own demesnes, but poaching was prevalent and not regarded as morally wrong. Rabbits were common and widely trapped. Hares, however, might only be hunted with dogs, never shot or trapped. Deer could supply a welcome bulk of meat and might be shot or trapped, but their scarcity made this rare and few people ever tasted venison.

Young game birds like young domestic fowls were stuffed and roasted, the older, tougher ones being boiled. Hares were usually boiled for soup, seldom eaten otherwise, but rabbits were roasted or stewed. A rabbit, stuffed with breadcrumbs and onions, was a prized dish on the Blasket Island.

In contrast to some other parts of Europe, the practice of 'hanging' meat or game for several days so that partial corruption might make the meat tender was generally viewed with revulsion in Ireland where *nua gacha bídh* was the accepted tradition.

Bread was baked every day. Bread two days old was stale, and the housewife would be ashamed to offer it to her family and much more so to a stranger. You might encounter several different kinds of bread. Most households had at least two kinds of flour or meal for bread making.

46. Pot oven and pot oven bread.

There was 'white flour' – bleached wheaten flour and 'brown flour' – whole wheat meal. Bleached flour came from the big mills in the towns and was less common in former times than the 'brown flour' which was ground in small local mills from wheat grown on the farmer's own land. Curiously, 'white bread' was more fashionable, although well known to be less nourishing, and 'shop bread', bought from a bakery, even more so. Many housewives were foolish enough to imagine that their guests should be given 'shop bread' rather than the much superior home baked. The same strange hierarchy extended to other kinds of bread. Oaten bread was less then wheaten, and barley still lower on the scale. In the oat-growing districts of the north-west, people envied the south-easterners who ate wheaten bread every day, while on some big farms in the south-east the workmen and servants got barley bread while the family ate wheaten. Lowest on the social scale was maize flour – 'yellow meal' or 'Indian meal', which is not surprising as it was first introduced to Irish country people as famine relief food. In the middle ages a lot of bread was made from ground peas and ground beans, and a few instances of such breads are still known from the nineteenth century. Most bread

47. Griddle and griddle bread.

was leavened, formerly with yeast, barm or sour dough but over the past century and a half increasingly with chemical leaven, usually 'bread soda' (sodium bicarbonate) but sometimes 'ammonia' (ammonium bicarbonate), the latter you may be surprised to learn, often still used in commercial biscuit making.

At least as much grain was consumed in the form of porridge as of bread. And all the various grains were used for porridge. Oats was the most usual but also wheat, barley and Indian meal, and formerly, peas and beans.

Here are a few types once popular but now almost forgotten:

Práipín – grains of wheat, oats or barley were 'browned' over the fire in an iron pot or frying pan, then ground coarsely in a quern. Milk or cream was poured over the freshly ground meal, salt or sugar added, and the lot eaten. Who said cornflakes are new?

Leithe faoi chupóig – thickly made porridge was allowed to stand until

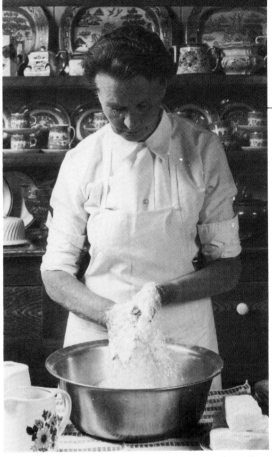

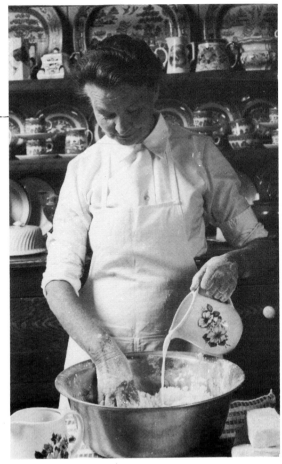

48. Making soda bread: mixing flour, salt and bread soda.

49. Sour milk added.

cold, then cut into thick slices which were wrapped in cabbage leaves or dock leaves and baked directly in the embers.

Porter meal – this was a favourite with pedlars, carters and other people who travelled. They carried a little bag of oaten meal and coming to an inn, they bought a measure of porter, mixed it with meal in a bowl, and as one informant put it, ate it sweetly. Of course a mixture of oaten meal and butter or cream or milk, eaten cold, was quite common.

In a country where butter was produced in huge quantity and used lavishly it seems odd that cheese had almost disappeared from use by about 1850 and became popular again only about 1950. We know that many kinds of cheese, both hard and soft, were made formerly, and not only of cows' milk but also of sheep and goats' milk. But by the end of the nineteenth century the tale was commonly told of a girl's remark on being offered cheese – *Más cailín ón dtuath mé ní iosfainn geir* – 'I'm a country girl all right, but I won't eat lard', as an illustration of how rare the eating

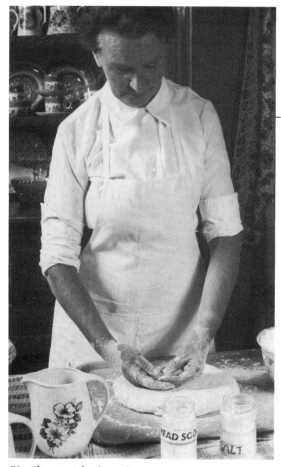

50. Shaping the bread.

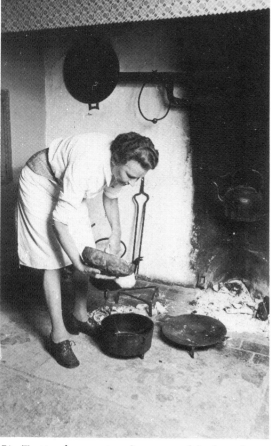

51. Testing by tapping the crust of the bread.

of cheese then was. Of course, this tale may be merely one of the popular 'foolish people' tales, of someone encountering something for the first time. Many of these were about food, like that of the woman who dyed cloth with a pound of tea or the man who 'gutted and cleaned' the sausages.

Milk was drunk in huge quantities and in many different forms – fresh milk, skim milk, buttermilk, sour milk, thick milk. Skim milk was what was left after the cream was separated; where this was done with a separator the skim milk was fresh, but formerly, when the milk was set in pans, the residue was soured into a sort of jelly, called 'thick milk' or *bainne reamhar*. 'Sour milk' was whole milk gone sour by accident, and was accounted a good drink, but the best of all was buttermilk, the residue left in the churn after the butter was made.

Fresh milk turned sour rapidly in the days before refrigerators and pasteurisation. Often a souring agent was used, rennet which was an

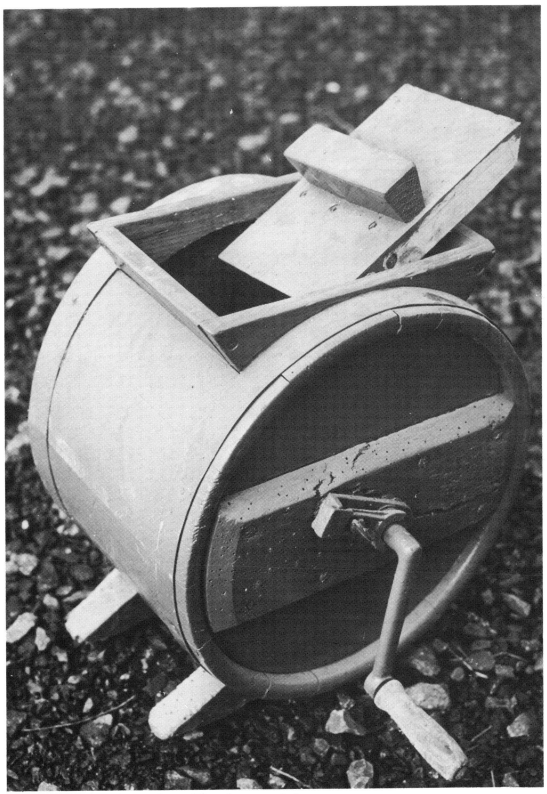

52. A popular form of a small hand-operated churn.

extract of calves' stomach lining, or the juice of butterwort or other plants. Sour milk separates into curds and whey. The whey is a clear faintly lemon-coloured liquid, and was held to be a very healthy drink for people in weak health. Curds were the solid white particles which, when strained from the whey could be pressed together to make soft cheese, which if kept long enough under pressure solidified into hard cheese. Soft cheese had to be eaten fresh, but hard cheese could be stored for eating when fresh milk was scarce.

Here are two formerly prized delicacies:

Curd cake – two measures of quite fresh milk were heated in a pot over the fire, and the moment it reached boiling point the pot was taken from the fire and one measure of sour buttermilk poured in, which produced a very thick solid curd when the whey was strained off. The curd was allowed to stand for a day or so, to drain, then formed into small cakes which were baked on a warm griddle until fairly solid. Some kind of flavouring, such as salt or sugar, with some caraway or cinnamon was usually added at the curd stage.

Cream cheese – to a pint of cream skimmed from the milk setting pan was added a pint of milk fresh from the cow. When this mixture broke into curds and whey the curd was strained off, flavoured with salt and a pinch of mustard, put into a cheese bag and hung up in the dairy for a day or two until it became fairly solid. This was thought to be a great delicacy.

Every farmhouse had its kitchen garden and orchard. Cabbage, choice varieties of potatoes, white and golden turnips, carrots and parsnips, onions and leeks were commonly grown to add to the variety of the family's diet. More adventurous gardeners ventured into cauliflowers, brussels sprouts, cucumbers and even asparagus and had begun to experiment with tomatoes. The red blossoms of scarlet runner beans and the faint purple flowers of a particularly tasty pea are vivid childhood memories of gardens in County Limerick sixty years ago. Most of this kitchen gardening is a thing of the past now; the tin and the frozen packet are so much less trouble – but unfortunately so much less flavoursome.

In the orchard you would always find apples and usually pears, often cherries and plums, always black currants and gooseberries and often red and white currants as well as raspberries, strawberries and loganberries, while even the smallest garden had rhubarb.

Then there was sure to be a portion reserved for flowers and herbs. Daffodils, Canterbury bells, sweet william, pansies and phlox – the old-fashioned flowers. And, of course, roses – the old garden roses that filled the evening air with scent. You would always expect to find thyme, sage, tansy, lavender and balsam, and a few plants of garlic in a corner. This

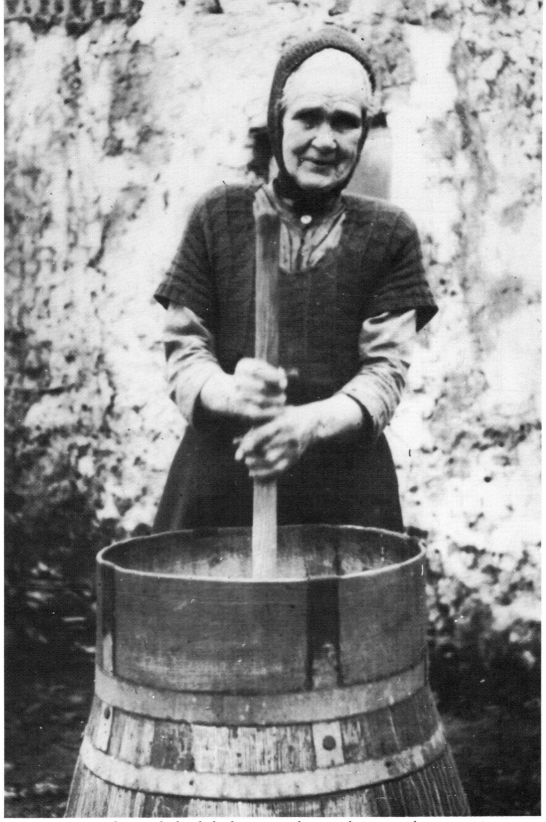

53. Butter-making with the dash churn was a heavy task. No wonder every visitor was expected to take a turn at it!

latter was in former days much prized as food flavouring, and was used to preserve butter, but this fell out of use and in recent times garlic was known only for its curative properties. Perhaps our new experience of Mediterranean holidays will restore garlic to favour as a cooking vegetable.

The Irish countryside did not offer very much of wild growth as basic or staple food, but there were delicacies to be found. Mushrooms, for instance, to be cooked fresh or made into ketchup. They were at their best and freshest when picked in the morning dew, and tasted best when cooked on a griddle, cups upwards with a pinch of salt in the middle. Hazelnuts were easy to find in most districts, but walnuts, once fairly common, almost disappeared entirely during the wars of the nineteenth century when walnut wood was the chosen material for gun stocks. If you found a walnut tree you did not tell every one about it! There were blackberries everywhere, and even when the children had eaten as many as they could, there were masses of them left over for blackberry pies and jam. On the edge of the heather you found fraochán, whortleberries, loved for their flavour, and eaten fresh with cream or in pies. If you could collect enough of them to make a few pots of jam you were very lucky indeed.

In some places crab apples grew in such abundance that they were fed to the pigs. So there was no excuse for not making crab apple jelly. Jam makers were busy in the autumn. I remember one household in the autumn of 1926, when fifty-five pounds of black currant jam, twenty pounds of gooseberry jam, fifteen pounds of loganberry jam and about thirty pounds of crab apple jelly were made. No one bothered with blackberry jam that autumn!

Two dishes which seem to have been forgotten in our urban kitchens are blackberry pudding, made by stacking up alternate layers of buttered white bread and blackberries in a deep pie dish, of course sprinkled with sugar and nutmeg, and apple snow made from a blending of the white pulp of roasted apples with beaten white of egg and sugar, the whole allowed to set in a deep bowl in a cool place and turned out like a moulded jelly.

Over all of these fruits and vegetables the potato towered like a giant. Like bread and porridge, the potato was a staple food. It can be said that everybody ate some potato dish every day. And the potato had a social as well as an economic status, both in inverse ratio to the consumers. The higher you were in the social and economic scale the less potatoes you ate, the lower the more. Where the well-to-do had a baked potato with their roast beef, the poor labourer was lucky if he had buttermilk to wash down his potatoes. Of course we must remember that a diet of good

potatoes with enough good milk is not only healthy and balanced, but has the great advantage shared with other simple foods like porridge or bread and butter, that it does not surfeit or cloy and can be eaten with good appetite day after day.

For the hard pressed or the lazy, potatoes are less trouble than any other food. To have bread, for instance, the corn must be reaped, threshed, winnowed, dried and ground. The flour must then be kneaded into dough and baked. But potatoes may be dug up and put straight into the embers of a fire to roast, dusted off, peeled, and there you are. All of this can be done without any tool, cooking utensil, tableware or cutlery. The greater the proportion of potatoes in your daily food, the less gear and furniture you needed, and several writers on Irish conditions of a century and a half ago remarked on the almost complete lack of household fittings in the typical *bothán* of the poor landless labourer. Potatoes were less respected than other foods. It was a shame and a scandal to throw bread, even crusts, away, but that did not apply to the potato. Another interesting fact is that corn and bread have attracted a lot of traditional belief and custom, but the potato hardly any.

Nevertheless the humble potato was highly valued, and was eaten in many ways, not only the boiled, fried, roasted, but in various preparations and mixtures, such as:

Staimpí. Raw potatoes were grated, put in a cloth and squeezed until all the juice was expelled. Flour was then blended with the potato pulp until it was stiff enough to form into cakes, some flavouring – sugar with caraway, ginger, nutmeg or cinnamon – having been mixed into the flour. The cakes, half an inch to an inch thick, were baked on a buttered or greased griddle; this was a popular dainty at harvest celebrations.

Stoilc. This was a dish of mashed potatoes mixed with boiled beans broken up small, and flavoured with salt and butter. It was, indeed a version of *cál ceannfhionn* ('colcannon') which was mashed potato mixed with chopped boiled white cabbage and finely chopped raw onions or scallions, with milk and butter added to taste.

Here are a few more traditional dishes now almost forgotten:

Pan kale – this was made by boiling oatenmeal and shredded cabbage together, with a flavouring of butter and salt, to a porridge consistency.

Pease pudding – yellow peas were soaked in water until soft, then mashed, flavoured with butter, pepper and salt, tied up in a pudding cloth and boiled for half an hour. It should turn whole out of the cloth.

Rice and turnips – rice and turnips are cooked separately and mixed together while hot, flavoured with butter, pepper and salt. A usual proportion was half a pound of rice to one pound of turnips.

Scotch cabbage – crisp white cabbage was shredded small, then dressed

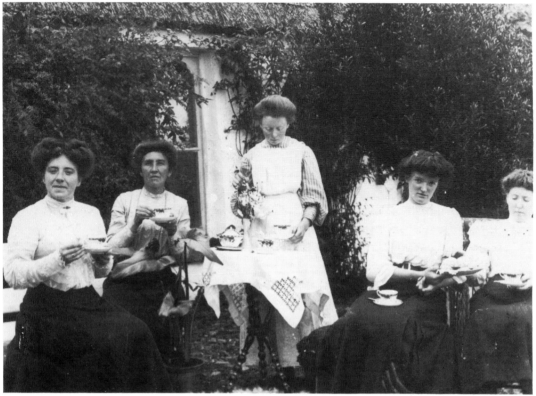

54. The new polite fashion – afternoon tea in the farmhouse garden. A photograph of 1908 in Co. Limerick.

with salt and sour cream. 'You'd eat your fingers after it.'

Leite bán – this was a dish for invalids and children. New milk was put to heat. Meanwhile some white flour was blended with a little cold milk, some sugar and, sometimes, spice being added, and put into the hot milk just as it came to the boil. This could be eaten hot or put in a bowl to get cold, when it would turn out like a jelly.

As to drinks, milk, sweet and sour, could be drunk at any hour of the day or night and with any meal. Tea became more popular as the nineteenth century went on; by 1900 it was a very poor household that did not drink tea at least once a day. There were various herb teas, such as dandelion, tansy, camomile or maidenhair fern, but these were medicines rather than beverages. Old people told of coffee as a popular drink at fairs, though seldom at home. Ale and cider were commonly made, especially in Munster and Leinster, particularly for such occasions as a wedding, a wake or a harvest home. Fruit drinks were made for children, for instance the core and peels of apples were boiled for a few minutes in water to make a drink said to be 'very healthy'. In the south-

west, especially near the sea, brandy and claret took the place held elsewhere by whiskey and beer – this was a relic of the old smuggling days. Home-made wines were not unknown, the favourites being elderberry, dandelion and raspberry. Súán ('sowans') was made thin for a refreshing drink or thick to become a jelly-like porridge. This was made by soaking the inner husk of oats in water for several days until fermented, squeezing the husks occasionally to extract all the value from them. It was then ready to drink. To make it into gruel it was left to stand a day or two more, when the liquid was poured off (it could be drunk) and the sediment boiled until it thickened.

There are traditions that in earlier times only two meals a day were eaten, bia na maidne (morning food) and bia tráthnóna (evening food). However by the late nineteenth century the 'three square meals a day' had become normal. To our pampered tastes the daily round of food and meals might seem rather insipid and monotonous, but we must remember that in most parts of the world for most people at most times food meant a few staples constantly eaten, with the occasional dainty as relish. Even on high festive occasions such as a wedding, the ideal was flúirse – 'plenty', lashings and leavings of quite ordinary food – washed down, of course, by a deluge of drink – rather than a wide variety of elaborate delicacies.

In a typical farmhouse of average prosperity the daily composition of meals about the year 1900 would be something like this. The first to rise raked the ashes from the smouldering fire on the hearth and soon had the kettle boiling to make tea, after a cup or two of which the first task of the day, milking the cows, was done. That completed there was time to sit to a breakfast of bread, butter, boiled eggs and tea. Some people had oaten porridge for breakfast, but even in 1900 that was going out of fashion. Many people liked cold boiled bacon, especially fat bacon, instead of boiled eggs. Then all hands were ready for the work of the day inside and outside.

Dinner was about midday, and the men came back from the fields to eat it in the comfort of the kitchen. With the gradual relaxation of the Penal Laws in the late eighteenth and nineteenth centuries numerous old Catholic customs were revived, among them the ringing of the Angelus bell. This is essentially a call to prayer but it also served the practical and welcome purpose of telling the time. When the bell rang at noon – and a bell should be heard all over the parish – it was time for the men to return to the house for dinner, and when it rang again at six in the evening it was time to finish work, except, of course, in harvest time.

Dinner always included and usually mainly consisted of potatoes

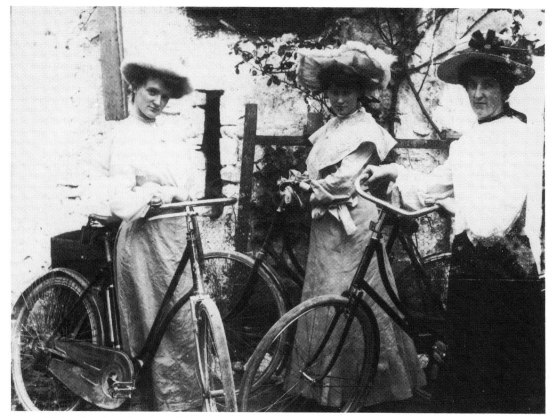

55. In the first decade of this century the coming of the bicycle greatly increased the range of social activity, especially for the young country woman.

boiled in their jackets, accompanied by some other vegetable, usually cabbage or onions but sometimes turnips, parsnips or carrots, and a sufficiency of boiled salt bacon. On Fridays people ate fish or eggs instead of bacon.

By 1900 the new custom of 'four o'clock tea' was well established, when the women of the household prepared a large container – usually an earthenware jar – of hot tea and a lot of sliced bread and butter and took it to the field where the men were working, when everybody sat down and took the refreshment.

After the work in the fields the men returned to the farmstead about half past six and undertook any task remaining to be done in the farmyard. Most important of all of these was milking, the time taken for which depended of course on the number of cows and of milkers. Three good milkers could milk and strip twenty cows in an hour, and a good milker knew that a cow responds to gentle handling, and took the proper time at the task.

Supper was about eight o'clock, and, as at breakfast, the staple was bread and butter. But usually the housewife had some little extra item at supper time, jam, honey or cold meat and home-made pickles, or a currant cake or an apple tart. A visitor was much more likely to be present at supper than at any other meal, and if a favoured young man was at the table you can be sure that the daughters of the house had prepared some delectable surprise for the supper table. Tea was the usual drink at this last meal of the day.

On Sunday, when people did not undertake heavy work – except of course the milking – there was time for some elaboration. Fried bacon and eggs for breakfast, roast meat or fowl for dinner, and perhaps a sweet to follow, a fry or a cake for supper.

Many poorer people had less variety than this typical farmhouse fare. Often there was no egg at breakfast and no bacon for dinner. In the old days, and up to the end of the last century, most farmers killed a bullock or two at the beginning of winter, and salted down the beef. Usually they gave pieces of this corned beef to their labourers on feast days. From this comes the belief in America that the Irishman's festive dish is corned beef and cabbage, carried to their new home by the great emigration of labourers after the Famine of the late eighteen forties.

Another memory of this killing and preserving of beef is the much prized spiced beef at Christmas.

5

Keeping Things Clean

The whitewash used on walls inside and outside was a solution of lime in water, made by blending powdered quicklime with water to the consistency of thick cream. Most quicklime was got by burning limestone – most of the product was used as fertiliser on the land, in which the ashes of the fuel (usually turf) used to burn the lime did not matter. But the 'good' lumps of quicklime were sorted out for use as mortar, plaster or whitewash. Good quicklime was pure white in colour. Along the seacoast a very good quality lime was produced by burning sea shells; it was usually a very pale yellow or cream colour. Whitewash is, in effect, diluted lime plaster. A good thick coat formed a protective skin on the surface to which it was applied. Damp weather will eat away an unprotected clay wall. Covered by numerous layers of whitewash it will last for centuries. Most parts of Ireland preferred plain white as a wall colour, but in some areas fashion called for colour, such as blue in west Clare, where a tablet of washing blue in the whitewash bucket gave the desired result, or the Cork-Limerick-Tipperary border districts, where iron oxide from the slag deposits of the Araglin ironworks gave a range of shades of red-brown-yellow.

Then there was quite a lot of woodwork to be painted. Externally there were the doors and window frames and inside the house the doors, windows, panelling, dressers, cupboards and so on. People made up their own paints. Colour in fine powder was blended with 'boiled' linseed oil and this mixture was reduced to a suitable painting consistency by adding turpentine. The most usual colours were the red-brown-yellow range from the umbers, ochres and sienas bought in packets at the shop. Red and white lead came in a thick paste form and were bought by weight; they formed the basis for many paint mixtures. Then there was lamp black to darken the mixture. Greens and blues could be had, but were not very popular because they faded quickly, whereas the reds, browns and yellows did not. The most popular colour, and the most serviceable was dark red, and tradition maintained that this was because ox blood had formerly been used in painting wood work.

Both whitewash and paint were applied by use of brushes, which might be home-made but were usually bought in the shop. A rough wall surface could be sprayed or sprinkled with whitewash by using a bunch of fine twigs or heather. Just before the great festivals of Christmas and Easter were the proper times for 'doing up the house' which included whitewashing and painting. This usually extended to all the buildings in the farmyard, and to gates, gate pillars and walls, especially those 'facing the road'. Neglect of this twice-a-year refurbishing was invariably ascribed by the neighbours to sluttishness or dire poverty, so that even the lazy and careless were encouraged to observe the tradition. Most people, however liked painting as a pleasant task, and children were eager to take part in it, while those who prided themselves on their skill in tinting, mottling, graining and stencilling came into their own.

There was a never-ending round of sweeping, dusting, washing, scrubbing. The kitchen floor was swept several times a day. The floor was swept towards the open hearth not towards the door. There were joking references to 'keeping the luck in the house and not sweeping it out' but the fact was that the easiest and cleanest way of getting rid of the sweepings was to sweep the dust and scraps into the fire and let them burn up.

A noteworthy fact about keeping things clean was that there was very little buying of cleaning implements and materials. Nearly all of these were made or provided at home. Brooms and besoms were made from heather, bound securely, without a handle for dusting and with a handle for sweeping; often made at home by a handyman, or by a local broom-maker. Other kinds of brushes, for whitewashing or painting could be made by securing bunches of bristles or horsehair or short lengths of teased rope in a wooden handle. One of the best possible dusters was the wing of a fowl, preferably a goose, and it was the handiest thing to brush crumbs from the table and poke dust out of corners and crevices, always remembering that a right-handed person should use the right wing of the bird, leading pinion upwards, curve towards the left. A loop of cord tied to the knuckle of the wing let it be hung on a peg or a nail.

In scrubbing furniture and wooden and cast-iron utensils a handful of coarse sand from the stream was vigorously rubbed on the surface to be cleaned by means of a wisp of coarse grass. There was to be found in many places a short heather locally called 'peck heath', so called from its use in scrubbing wooden pecks and other dairy utensils. A handful of this, quickly and skilfully twisted into a small pad and used with sand, was as effective as any modern steel-wool cleaner on greasy pots, wooden vessels and platters or furniture. Kitchen tables and chairs were usually of

56. Washboard and tub for laundering clothes.

unpainted wood, and when scrubbed white were the pride and the boast of the woman of the house.

Near the hearth hung the knife box, which had not a single knife or implement in it. It was a flat board about thirty inches long and five or six inches wide, with a hole at one end from which it hung on a nail and at the other a small open box holding a couple of pieces of cloth and a quantity of fine sand or brick dust or a piece of bathbrick. This board was laid on the table, a pinch of dust or sand put on it and the knives rubbed vigorously on it until they shone. The same dust or sand was put on a piece of coarse cloth to be rubbed to the forks and spoons; a small square of baize or felt was the ideal polisher. Stainless steel had not yet appeared, so that cleaning the knives was a weekly task, usually falling on the children on Saturday. Of course, some enterprising housewives had procured for themselves one of the new fangled mechanical knife cleaners.

Worn out bed sheets, old garments and the like were torn up into handy pieces to serve as dish-rags and cleaning cloths, which might be seen to descend in the social scale until finally discarded, first used to dry the tableware, then to scrub pots and so downwards until, torn and stained they were grabbed up to wipe tar off hands or old grease off a cart axle.

Some people still made their own soap. For many centuries it was known that the ashes of certain plants dissolved in water was a good cleaning agent. Then, about a thousand years ago some inventive genius found that this solution of ashes reacted on oil or tallow to produce a still more useful cleaner, soft soap, and later methods of making hard cakes of this were discovered.

A simple way to make household soft soap was to mix a solution of the ashes of ferns in water with the proper quantity of rendered animal fat. Used in the right proportions the reaction of these substances produced sodium stearate, namely soft soap. A further simple process of blending and boiling produced a good hard or semi-hard soap, but most people were content with soft soaps until brands of manufactured soap, like 'Sunlight' and 'Lifebuoy' began to appear in the village shops.

At the end of the last century clothes and household linen were still made of tough natural materials, wool, linen, cotton, calico and so on. These stood up to vigorous washing – they could be boiled, beaten, scrubbed, twisted, wrung and squeezed without damage. And they were put through all these ordeals. Fine linen shirts, blouses and underwear were boiled in soapy water in the big iron pot. Some larger farms had a boiling-cauldron, a 'boiler', in the farmyard, which the housewife took over on washing day. Cotton could be treated like linen, and nearly all

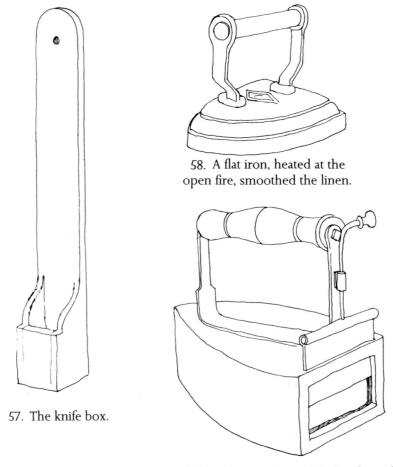

57. The knife box.

58. A flat iron, heated at the open fire, smoothed the linen.

59. A box iron; a shaped block of metal was 'reddened' on the fire and slapped inside the iron.

the garments, sheets and table linen were white, so there was no fear of colours running.

Wool had to be washed in cooler water – 'just hot enough for your hands'. This was usually done in a tub with a washboard. Blankets and woollen quilts were usually washed in big tubs by barefoot girls trampling on them. In many places the whole family wash was carried to a washing place on the bank of the stream, where the clothes were dipped, soaped, beaten with bittles on a flat slab of stone, rinsed repeatedly in the running water, then vigorously wrung and spread on the bushes to dry. In some localities there were communal washing places shared by the women of several households , and these were popular meeting places, and, indeed, attracted their own share of tradition. For instance, the girl who washed her shift against the current at Shrove or at Hallowe'en would dream of

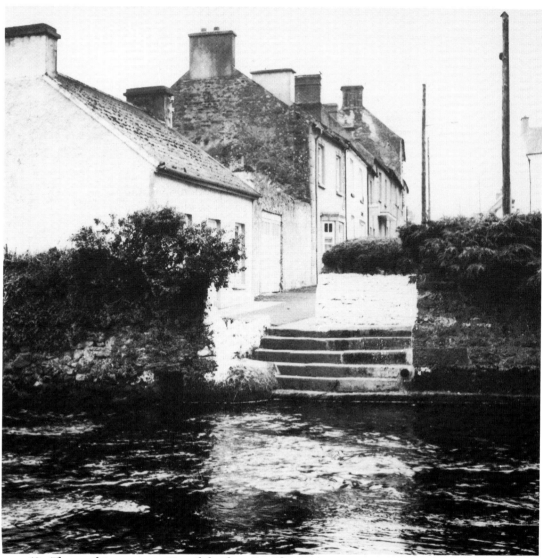

60. The washing steps at Sixmilebridge, Co. Clare.

her future husband, and at some of these places a ghostly washerwoman appeared to foretell future calamity.

The starching of clothes was very popular. Starch was made by grating raw potatoes and squeezing out all the liquid. This was left to stand until all the solid matter – the starch – sank to the bottom; this could be used while fresh and damp or dried and stored. Blouses, shirts, collars, cuffs, table cloths and napkins, and even sheets and pillow covers for grand occasions were starched and ironed until they resembled polished metal, and no protest from the menfolk about choking collars or cast-iron shirt fronts had any effect on the housewife's pride in spotless linen on Sunday morning.

By the end of the last century there was an invasion of the household by new inventions and products. Soap, starch and washing blue, brushes of all sorts from the heavy yard-brush to the genteel crumb-brush, mangles and washing machines, mincers, sewing machines and dozens of others. The days of self sufficiency were drawing to an end.

As to personal hygiene, people took a pride in being clean, and children were scrubbed unmercifully. Not that being bathed in a wooden tub in front of the warm fire was unpleasant, but scrubbing behind the ears and soap in the eyes were as unwelcome then as now. Adults bathed discreetly in a bedroom, with a couple of buckets of hot water in a wooden tub in which one stood to scrub down.

In those pre-wellington days all who worked or played outdoors washed feet as well as hands and face at night. And for some reason the water used to wash feet was never to be kept inside, but must be thrown out at once, otherwise it might admit some unwelcome thing to the house in the night. And it must not be thrown out into the yard gutter without the warning *seachain!* or *chughaibh an t-uisce!* 'look out' or 'water towards you', so that any unseen neighbour who might be there could step aside in time.

Women were, of course, rightly proud of their hair and always took care to have it clean and shining, and many secrets as to the use of this or that to enhance its beauty were passed around.

Throughout the history of mankind a battle had, and still has, to be waged against animal and insect pests and parasites. The traditional outlook on these varied curiously. Flies were dirty and should be killed, but while sweeping off cobwebs nobody would willingly kill a spider. Mice were trapped when they became a nuisance, while rats were hated and killed by all possible means. The dog and the cat proved their worth here. Cockroaches were looked upon as filthy and were shown no mercy, but crickets were friends and were never harmed. Fleas were disliked and the house purged of them, but an occasional flea which might come from a dog or a dead rabbit was treated as something of a joke. But there was no joking about lice. They were a sign of utter filth and degredation. Children were deliberately frightened of them by being told that they would be eaten alive or carried off and drowned by them, so that they screamed and ran if they saw one. Bed bugs, luckily for country people, were a pest of the towns and most country people had never seen one.

Thus, washing and cleaning formed a large part of household routine with recurrent daily, weekly, monthly and yearly tasks to keep the housewife and her helpers busy and the house, its goods and its occupants old and young 'as clean as a new pin'.

The three factors which utterly changed the course of household economy in Ireland, as elsewhere, were piped water, enclosed stoves and ranges and electrification. All of these had spread into even the most remote districts by the end of the nineteen fifties, and with radio and television to spread the latest ideas, have ended forever a great body of crafts and skills and enterprises by which our recent as well as our remote ancestors lived. This is no matter of regret. We can take pride in the ingenuity and competence of our forebears while enjoying a degree of material comfort that they never knew. But there may be, in the back of our mind, the nagging thought of our increasing dependence upon outside sources and circumstances beyond our control for most of the means of life, and a slight unease when we wonder if we could meet loss and calamity with their self-reliance and adroitness.

6

When They Got Sick

The normal instinct of a child in pain or distress is to run to mother for comfort. And so mother becomes the healer, a function which extends to taking all the members of the household, young and old into her care. Nowadays we run to the doctor and the public health service, but a century or so ago there were fewer doctors and little public care of health, so that all but the most serious cases had to be treated at home, and the treatment, for the most part, fell to the lot of the women of the house.

Around the house, in the workshop and on the farm minor accidents were to be expected as part of the daily routine. Scalds and burns, cuts and scratches, sprains and bruises might occur at any time and had to get attention.

The usual treatment for burns and scalds was some kind of plaster which excluded the air, which is an effective and excellent healer if infection is avoided. Many different plasters were used. A simple dressing was a wrapping of the burned or scalded area with cloths or bandages soaked in a blend of friar's balsam and linseed oil or of linseed or olive oil, limewater and egg white. This excluded the air, soothed the pain and was mildly antiseptic. Other plasters or salves for burns were made from mutton fat, mixed with a little beeswax, or a mess of mashed-up fresh green cabbage leaves (this was also used for wounds and sores as well as burns). The plaster should be put on as soon as possible, since any delay might lead to infection. An instant first aid for a scald or burn was to apply a wad of cloth soaked in cold water, or to immerse the burned hand or foot in a vessel of cold water. Some people used a plaster of cowdung or mixed cowdung and tar; this, by was the way, was a regular ploy of the qualified doctor and the official hospital up to the eighteenth century – it is highly recommended by Dr John K'eogh in a medical text published in Dublin in 1739, and is by no means the most repulsive nostrum approved by that worthy savant and by most of his professional colleagues.

Some people shrink at the sight of blood, but the mistress of a large household must be ready to meet it at any moment. And let it be said that

in facing blood most women were braver than most men. Be that as it may, cuts and scratches need instant care, and common sense prevailed here – clean the wound, staunch the blood, cover with a healing and soothing pad or bandage. A clean cobweb applied to a small wound stopped the blood. A wisp of moss or a tuft of hair was similarly used. *Slánlus* (broad leafed plantain) or *lus na fola* (yarrow) was mashed, applied to the wound and bandaged over. Often, if cut when working away from home the injured person would chew a handful of one of these herbs and apply it to the wound.

More serious wounds had to be sewn, and some women were brave enough to do this with a needle and waxed thread. If possible a tourniquet was applied to halt the bleeding. A bleeding nose was usually treated by applying something cold to the back of the neck and leaning the sufferer back until the bleeding stopped.

A wound which had turned septic was treated by dressing with an ointment made of blue mould cultured on slices of bread kept in a dark damp place, blended with unsalted butter or goose-grease. This had been in use for hundreds of years and is, of course, a crude version of penicillin.

Thorns and splinters might give trouble if broken off within the puncture, when probing and digging would aggravate the wound. Usually a stubborn fragment was coaxed out by the application of a plaster of soap-and-sugar, or cobbler's wax, or fat salt bacon. A very odd but highly vaunted remedy was the application of a fox's tongue to the affected part.

Boils and similar afflictions were treated with blue mould or soap-and-sugar, and, in serious cases were opened or lanced in a variety of painful ways. Ulcers were usually treated by bandaging with poultices of herbal remedies, some of which might be beneficial.

Skin ailments were usually treated with salves and ointments of which many were known. A degree of magic entered here, as it did, indeed, in all medical treatment, official and unofficial. The muttered charm of the folk healer differed very little from the mumbled Latin phrases of the qualified doctor, nor did the written charm from the mysterious prescription to be taken to the chemist in the town. And who could declare that the fasting spit or water from the blessed well was less effective than some extract of earth or bark from a South American tree?

Headaches, earaches and toothaches are among the most painful and distressing ailments imaginable. Local applications to soothe or deaden the pain were at once applied, cold compresses on the head, warm oil in the ear and something powerful like tobacco, mustard, clove oil or ammonia was applied to the tooth. A persistent toothache with swollen jaw was warmly bandaged, but of course, it was well known that the

ultimate remedy was a visit to the dentist, be it local blacksmith, itinerant quack or qualified man in the nearest town.

The remedies for coughs, colds and infections of the nose, mouth and throat and the lungs were usually soothing and pleasant, such as a potion of linseed oil or vinegar mixed with sugar or honey. Garlic and honey was highly regarded, as was a mixture of whiskey, liquorice, honey and egg. There were dozens of similar decoctions.

Lung afflictions such as bronchitis, asthma and pneumonia often were not clearly distinguished from each other, and the treatment tended to be much the same, a poultice on the chest. There were many forms of poultice, from bread mashed in hot water to linseed to brown paper coated with candle grease.

Inhalation of the steam of water in which aromatic herbs were boiled gave comfort and relief to chest and head colds. The steaming basin was put on a table and the patient leaned over it covered with a blanket to trap the steam.

'Pains in the bones', that is to say, rheumatism, sciatica, lumbago and arthritis were treated by massage, the medium used usually being goose-grease, although seal-oil was valued by people who lived near the coast. The value of sweat baths was well known. Some districts had their *tithe allais*, sweat houses, little stone or earth cells which could be thoroughly heated and in which the patient sat and sweated profusely. Within the home the patient would sit on a chair under which a large vessel of hot water was placed. Herbs strewn in the sweat house or in the hot water helped the cure.

There were, of course, ailments which went beyond the skill of the housewife. Broken bones, for instance, had to be referred to the local bonesetter. Tuberculosis, cancer, appendicitis might yield to care and treatment but were more likely to kill, and the murderous epidemics, diphtheria, cholera, typhoid, smallpox and others were viewed with dread.

The draught of salt-and-water or senna tea which settled indigestion might be fatal if the pain was caused by peritonitis, and so on in many ailments where only the symptoms could be seen and real diagnosis was impossible.

As time went on patent medicines began to appear, many of them bearing the name of a physician, Doctor Browne's Chlorodyne, Doctor Sloan's Liniment, Doctor Bowditch's Toothache Remedy and Doctor Dunbar's Alkaram Cold Cure, as well as Zam-Buk and Cuticura, Antiphlogistin and Bragg's Vegetable Charcoal, Mrs Cullen's Powders and the Carbolic Smoke Ball, some of which have disappeared long ago but some of which have still a reputation. These were added to the

camphorated oil, boric ointment, sulphur, cod liver oil, epsom salts, seydlitz powders and other cures and tonics already in the family cupboard.

Most of all the healing skill of the housewife lay in her talent for inspiring confidence in her patients. Reassurance is still a most important part of any treatment, and those who can impart it have already vanquished more than half of the suffering. To 'kiss the place and make it well' is a very effective remedy.

61. Greenstuff, chopped with this knife, was added to the fowl's food.

62. The candle lantern, made by a travelling tinker, was most useful in the yard at night.

7

Out in the Yard

In traditional Irish farming practice there was a clear division between the work and responsibilities, the duties and privileges of the farmer and the farmer's wife. The work in the fields was his affair, that in the house was hers. In the farmyard their work and their control overlapped. This was very important to both parties, for it included the right to the profit of the various enterprises. The right of a woman to be an independent money earner has always been recognised in the Irish countryside. The farmer's wife was in charge of the dairy and the fowl run. She saw to the butter-making, the storage of eggs, the killing of fowl, and she took the produce to market or dealt with the travelling buyer, and, most important, she kept the money thus gained at her own disposal. And she shared this activity with her daughters. Even little girls were given a hen or two to care for, and proudly went to market with mother to sell a little basket of eggs and spend or save the pennies thus earned.

Butter-making could be a small task with a dash churn to provide the family's needs and leave a few pounds over for sale, or a big enterprise with the cream from thirty or forty cows and a big churn driven by horse power or a water-wheel. In the same way, a farmyard fowl run might hold half a dozen hens or half a hundred geese or turkeys for the Christmas market. In all cases these were the concern of the mistress of the house, the famer's wife, who might manage the small task alone or have half a dozen women, daughters or servants, to speed the larger endeavour.

A well-managed and well-equipped dairy was a source of pride as well as of profit. The cool stone slabs for the milk pans, the flagged floor swabbed out every day with clean water, the shining earthenware crocks and jars, the wooden vessels scrubbed white, the churns, the working troughs, the roller, butter-prints and paddles all shining clean made a sight worth seeing, and proudly displayed, and the coolness of the dairy on a summer day, the sweet-sour smell and the taste of a mug of buttermilk after taking a spell at churning or at least laying a hand on the churn so as not to take away the luck of the dairy, all of these leave

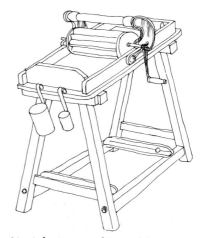

64. A butter-working table, used in large dairies, to mould the butter and squeeze out the water and buttermilk.

63. The separator, a later nineteenth century invention, brought change in butter production.

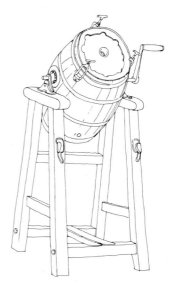

65. The tumbling churn was very popular in medium-sized dairies.

memories of good times gone by, while the hum of the separator and the splash-dash-wallop of the churn are sounds that remain in the ear.

Butter and butter-making were very vulnerable to evil influence and the malice of those who tried to steal by magic. There were precautions to be taken, prayers and charms to be said, holy things such as water, fire and iron to be properly employed to avert the malevolent powers of the butter stealers with powers all the stronger from being benign.

The fowl run was much less menaced by unseen forces, but needed its

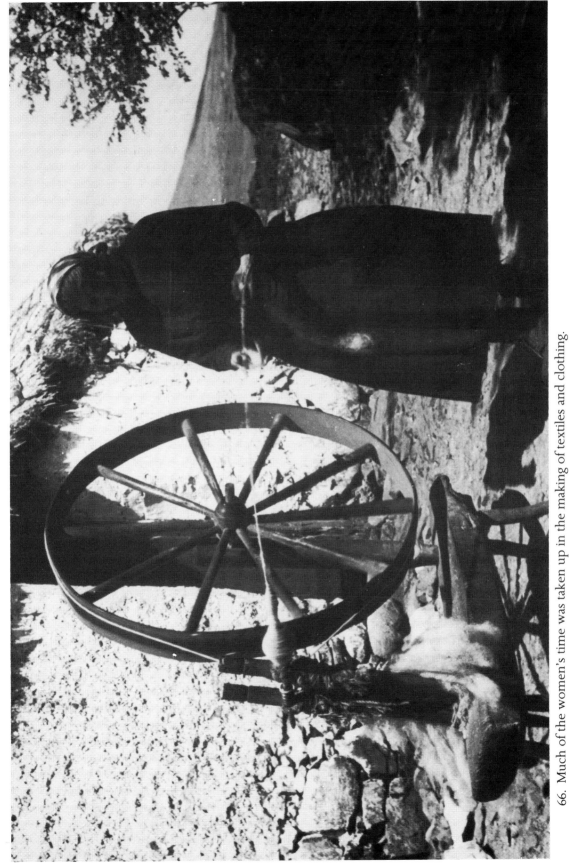

66. Much of the women's time was taken up in the making of textiles and clothing.

own share of work and care. The birds had to be properly fed and cleanly housed, and carefully watched for any symptoms of the diseases which afflict domestic fowl. There were six species of fowl, hens, ducks, geese, turkeys, guinea fowl and pigeons, of which only hens and turkeys are now common but all of which were formerly popular. A pair of peacocks might be kept for ornament and novelty but were much more likely to occur on the lawn of the big house than in the farmyard.

Hens had to have ground on which to scratch for worms. Ducks needed water in which to swim and to hunt for snails and frogs. Geese are natural grazers and should have green pasture. Turkeys were tricky creatures easily subject to infection and liable to fits of panic. Pigeons foraged for themselves and fattened on the grain dropped in the harvest fields which would otherwise be lost. The cry of the guinea fowl was believed to frighten away rats. Each species had its own characteristics which must be taken into account. The care of young animals such as calves or orphaned lambs often fell to the housewife's lot also.

The housewife kept a jealous eye on the farmyard to make sure that it was kept clean and orderly as far as its everyday activities permitted. Such women servants as there were, came under her direct control and supervision, as did, usually, the servant boys who worked in the farmyard when she needed their services to move heavy cans or bring in fuel or water, or ply broom and whitewash brush.

With all that work and care both inside and outside the housewife was a very busy person, the mistress of many skills and talents. Nowadays her task is much lightened by labour saving devices of all sorts, most of them coming from electric power and piped water, so that her grandmother would wonder, were she there to see, what she could possibly do with all the time saved, while the farm housewife of today, as busy as ever, may well wonder, in her turn, how her grandmother managed to get through the endless tasks of the day and was still smiling when evening came.

List of Illustrations

Bunratty House. *Opposite page 7*

1. The half-door kept the small children in and the animals, large and small out; it also gave welcome ventilation.
2. The Shannon farmhouse.
3. The 'covered-car' bed.
4. The Mountain farmhouse.
5. Inside the Mountain farmhouse. Note the open loft and the door to the lower room with china press on one side and flour bin on the other.
6. The Cashen fisherman's house.
7. The hearth in the Cashen fisherman's house; note the simple hanger for pot or kettle.
8. Inside the Loop Head farmhouse. The wooden partition has a dresser and press set into it.
9. The Loop Head house, with its small yard.
10. The Golden Vale farmhouse, home of the strong farmer.
11. The comfortable kitchen of the large farmhouse with its entrance lobby and well-equipped kitchen.
12. The *Bothán Scóir*, the poor labourer's house, is in stark contrast to the strong farmer's house.
13. A type of house that has disappeared forever.
14. The Byre house in which people lived at one end and cows at the other.
15. The bare hearth of the labourer's house.
16. The outshot bed.
17. A good example of local materials in expert use, the Moher farmhouse.
18. The village with its typical shops.
19. The village.
20. Pub and pawn shop flank each other – is there a lesson there?
21. The bar in the village pub.
22. The well in the yard.
23. Drawing water from the well of an obliging neighbour.
24. Well laid masonry; a roof of heavy slate and flagged yard, all typical of north Co. Clare.
25. Expert stone-laying in the out-buildings of the Moher house.
26. The hearth in the Mountain farmhouse with its crane.
27. The hearth of the Byre dwelling with stone seats on each side.
28. The typical Burren hearth with its stone arch. Note the flagged floor and shelves of stone slab.
29. The spit dresser.
30. A dresser filled with shining delph, speckled and white and blue and brown.
31. Another form of dresser. Above a rack of plates and dishes, below a coop for hatching fowl.
32. The 'falling table'.
33. The typical Irish chair, a Mediterranean-Atlantic form.
34. Shelf over the hearth displaying family treasures.
35. The height of fashion in 1900 – the brass bedstead.

36. The settle bed which folded up to make a seat bench.
37. The 'press bed' which folded up to look like a sideboard.
38. The children, in the bed loft, were still part of the company in the kitchen.
39. The parlour of the Golden Vale farmhouse.
40. Much parlour furniture, like this chair, was made by local craftsmen on the model of fashionable styles.
41. An early form of oil lamp.
42. A scallop shell full of fish oil, with a wick made with a string, made a simple lamp for seacoast dwellers.
43. The local blacksmith made this combined rushlight and candle holder.
44. The candle-maker at work.
45. Fish drying on a wall.
46. Pot oven and pot oven bread.
47. Griddle and griddle bread.
48. Making soda bread: mixing flour, salt and bread soda.
49. Sour milk added.
50. Shaping the bread.
51. Testing by tapping the crust of the bread.
52. A popular form of a small hand-operated churn.
53. Butter-making with the dash churn was a heavy task. No wonder every visitor was expected to take a turn at it!
54. The new polite fashion – afternoon tea in the farmhouse garden. A photograph of 1908 in Co. Limerick.
55. In the first decade of this century the coming of the bicycle greatly increased the range of social activity, especially for the young country woman.
56. Washboard and tub for laundering clothes.
57. The knife box.
58. A flat iron, heated at the open fire, smoothed the linen.
59. A box iron; a shaped block of metal was 'reddened' on the fire and slapped inside the iron.
60. The washing steps at Sixmilebridge, Co. Clare.
61. Greenstuff, chopped with this knife, was added to the fowl's food.
62. The candle lantern, made by a travelling tinker, was most useful in the yard at night.
63. The separator, a later nineteenth century invention, brought change in butter production.
64. A butter-working table, used in large dairies, to mould the butter and squeeze out the water and buttermilk.
65. The tumbling churn was very popular in medium-sized dairies.
66. Much of the women's time was taken up in the making of textiles and clothing.